IMAGES
of America

AROUND
FINDLEY LAKE

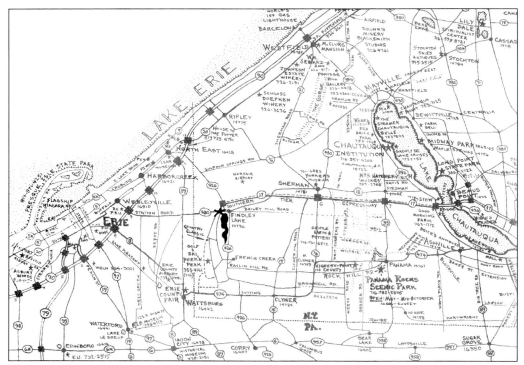

This map shows the relationship of Findley Lake to other area towns in Pennsylvania and New York State. (Courtesy of Art and Mary Cooper.)

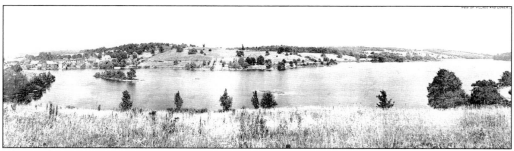

This early-1900s panoramic postcard view of the lower end of Findley Lake was copied from a famous set of photographs that showed this view and also a view of the upper end of the lake with the Big Island. Those sets of two photographs are hanging in many cottages around the lake today. (Courtesy of Randy Boerst.)

At one time my mother said her great-grandfather & Dad's great grandfather lived in next door houses — side street in Findley Lake! (I saw Both houses once had Price Been torn down) 1970s/1980s ?

IMAGES
of America

AROUND
FINDLEY LAKE

Randy Boerst

I remember my family Dad saying this family had been left out of this — (+ my mother)!

ARCADIA
PUBLISHING

Published by Arcadia Publishing
Charleston, South Carolina

Printed in the United States of America

Library of Congress Catalog Card Number: 2002116098

For all general information contact Arcadia Publishing at:
Telephone 843-853-2070
Fax 843-853-0044
E-mail sales@arcadiapublishing.com
For customer service and orders:
Toll-Free 1-888-313-2665

Visit us on the Internet at www.arcadiapublishing.com

To my wife, Theresa, who agreed to move to Findley Lake from her hometown of Baltimore, Maryland, and her family nearby. Giving up our ownership in four Chesapeake Bagel Bakeries and a secure future, we followed a dream of returning to and living on Findley Lake.

Greetings From
FINDLEY LAKE, N. Y.

I know that you would like this
town,
So I'm sending you this
rhyme
To say I wish you'd meet me
soon.
We'll have a jolly time

To all past, present, and future Findley Lakers, I hope this book brings back many fond memories and inspires you to preserve your own Findley Lake heritage. (Courtesy of Jerry Tenbuckel.)

CONTENTS

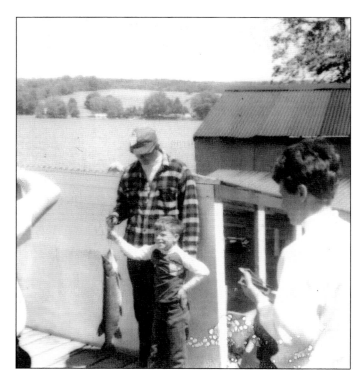

This is where my fascination with Findley Lake and its history began, at the cottage of my grandparents, Roland and Ruth Loomis, on Shadyside Road in the late 1960s. My father, Jim Boerst, helps me hold a muskellunge that we caught together on the lake that morning. (Courtesy of Ruth Loomis.)

Acknowledgments

Special thanks go to the following people for their generous contributions, advice, support, time, and their many photographs, all of which energized me during this project: George and Virginia Boozel, Art and Mary Cooper, Robert and Christie Ferrier, the Findley Lake and Mina Historical Society, Mary Norcross, John Swartz, and Jerry Tenbuckel.

My sincere appreciation also goes to the following for their various contributions: John Abbott, Robert and Barbara Allen, Jay and Vicki Altman, Evelyn Babcock, Better Baked Foods, Ruth Blair, Jim and Sue Boerst, Theresa Boerst, Florence Boozel, Peg Bourgeois, Lynn Breslin, Rebecca Brumagin, Carol (Shields) Burke, Tom Carangi, C & C Printing, Doris Durst, Becky Faulkner, Christine Froess, Johnny Gibbons, Kaki (Selkregg) Griggs, John Hallenburg, Jack and Sherri Hamilton, Barbara Henry, Hill Engineering, Peter and Barbara Howard, Millie Keith, Lola King, Linda Lawrence, Anna Lewis, Jeff and Marge Lewis, Ruth (Selkregg) Loomis, Jerald Mathews, Jan (Meese) Mayo, Carol Mellin, Halcyon Mueller, Barbara Neckers, Ken and Barbara Neckers, Peek'n Peak Resort and Conference Center, John C. Peterson, Rex and Joan Proctor, David and Kris Quast, Steve and Patti Quast, Larry Rater, Bob Roache, Jody (Meese) Roberts, Judy Schilberz, Nancy Seevers, Marie (Hill) Sessions, John and Sue Shifler, Bob Skellie, Marty Smith, David Swartz, Jeff TeCulver, Shirley TenHagen, Chip and Teresa Williams, and George and June Wright.

The courtesy lines identify the image contributors, to whom I am extremely grateful.

INTRODUCTION

Findley Lake sits modestly and quietly among the hills of Chautauqua County in the Town of Mina. It sits at 1,420 feet above sea level, which is the highest elevation of any of the lakes in the area, including Lake Erie. Art Cooper Jr., a longtime Findley Lake resident, tells a fascinating story of why his family moved to Findley Lake in the early 1900s. Cooper suffered from an ear infection at the age of two and had a family doctor put a hole in his eardrum to try and dissipate the infection. His father, who was the purchasing manager at General Electric in Erie, Pennsylvania, was told by that same local doctor to move his son to higher ground. Art Cooper Sr. looked on a map and saw that Findley Lake had the highest elevation in the area and immediately moved his family to Findley Lake in the Town of Mina. Art Cooper Jr. recovered from his ear infection, losing hearing in only one ear.

There are no railroads that cross the village's boundaries and no industrial plants, oil wells, or mines. The area's only natural resources are all in the forests and farmlands. The soil is very fertile and well watered. The climate is cool and mild. The principal foliage crops are grass, corn, and small grains. Dairy farming was the principal occupation of the older landowners, and it was passed down from generation to generation. In this area of farms and farmland, the body of water, Findley Lake, is the most notable and prominent feature.

The Holland Land Company purchased all of southern New York State in 1795. By c. 1810, the company had finished surveying the entire area into ranges, townships, and lots.

Chautauqua County was established in 1811. In this same year, a man who was born in Ireland of Scottish parents was looking for a place to build a mill site. He had migrated to America c. 1790 and settled near Pittsburgh, Pennsylvania, with his wife, Nancy, and his first two sons, William and Russell (who had been born on the ocean voyage to America). By 1809, Alexander Findley had built a house in nearby Greenfield Township, located in Erie County, Pennsylvania, but he desired a place to build a sawmill. He seemed to think that he may find this area somewhere on the French Creek and followed the stream to the source of its northernmost branch. It was here that he found exactly what he was looking for—two ponds, both with islands on them, joined by a sizeable stream and surrounded by a dense wilderness of huge deciduous and hemlock trees.

The Holland Land Company sold Findley the land containing lot 52 in 1811. This lot also contained the dam site, on which he had already built before the original deed was sold and recorded.

In 1815, Findley built the sawmill and rebuilt the original dam. This raised the water level to a height of 10.5 feet, which flooded the area around the two ponds to form the one big lake that is present today. Soon after he finished building the sawmill, which was important so that the early settlers could start building, he built his home and a gristmill. The gristmill was needed for

grinding grain, which was also very important to the early pioneers. By 1827, he had erected a carding mill that was used to card, spin, and weave wool.

The dam site became the base of the highway crossing and eventually a part of Main Street in this little but growing hamlet. By the 1890s, a family could purchase just about everything that it needed for daily life in the prosperous village of Findley Lake.

The remainder of the history from this point will be told in the ensuing images and advertisements. This book is designed to be only an overview of the history of the Findley Lake area from c. the 1890s to the 1970s.

Because of the outpouring of generosity of the many contributors, I had to agonize over the image selection, attempting to share only those of the very best quality and the most representative of the time period. I also realize that every photograph has its own individual story and importance to someone. I want to encourage everyone to value their family photographs, preserve them, pass them along to your future generations, or donate them to your local historical societies so those individual memories and histories survive.

This endeavor was a nostalgic labor of love intended to show the rich and enduring history of the Findley Lake area to past, present, and future property owners who are inquisitive about why certain things are the way they are. I have made every effort to ensure historical accuracy. I hope that after reading this you will enjoy the history of Findley Lake as much as I do. For further information about the Findley Lake area, please visit the Findley Lake and Mina Historical Society in the community center, North Road, Findley Lake, New York, 14736.

Welcome to Findley Lake, our little Brigadoon.

—Randy Boerst

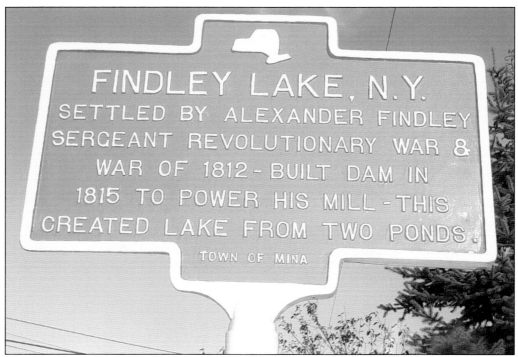

This historic marker is prominently displayed at the head of Findley Lake on Main Street. (Courtesy of Randy Boerst.)

One

TRAVELING DOWN
MAIN STREET

Main Street developed around the sawmill, carding mill, and gristmill that Alexander Findley built by 1827. The period after the Civil War was a prosperous time in Findley Lake. Many houses were built along Main Street, and by 1873, a carriage shop, a hotel, a union school, the United Brethren Church, and a photography gallery were operating along with the mills.

The mills continued to dominate Main Street until 1948, when the buildings and property were sold by the Swartz family to the newly formed Findley Lake Property Owners Association. Included with the purchase of the property was the actual ownership of the lake and control of its water level. This right had been passed to each successive owner: Lawrence Swartz, Louis (Lewis) Swartz, Phillip and Louis Swartz, Ebenezer Skellie, W.J. Pratt and H.L. Bush, William Selkregg, Robert Corbett, Hugh and Carson Findley, and Alexander Findley. Each time, the deed conveyed the right to keep the dam height at 10.5 feet.

As in many small towns, the Main Street in Findley Lake has seen boom times and down times. A devastating fire in the winter of 1912 burned down part of the south side of Main Street, along with several businesses. The townspeople who started a bucket brigade on that Christmas Eve saved the entire business district on Main Street from totally burning down. Another fire on Main Street in 1919 burned several other businesses, including the Hotel Laurene on the north side of the street. The Hotel Laurene stood where the fire department building and part of the parking lot is today. It evolved from one of the very first Main Street businesses, which was operated by James W. Robertson.

As times changed, so did the makeup of Main Street. The harness and carriage shops gave way to automobile garages and gas stations. The tin and blacksmith shops turned into antiques shops or general stores. The hotels reopened as general stores. New businesses opened to serve the influx of people in Findley Lake who were traveling by automobile. Car dealerships were operated by W.L. Nuttall, then the Chesleys, and finally the Proctors. Meat markets were run by the Hulburt and Smolk families; the Smolks also ran the Grange League Federation building. Different businesses opened to serve the expanding tourist trade. Lawrence Swartz, Wink and Millie Keith, Gilbert and Maudie Cray, Bud and Judy Noble, and others operated various restaurants on Main Street.

By the early 1970s, Main Street in Findley Lake was pretty run down. Many businesses had closed and never reopened. Buildings that were built at the beginning of the 20th century

had started to show their age. More and more people were traveling to Erie, Pennsylvania, and Jamestown, New York, to do their shopping, and were avoiding Findley Lake altogether. The many cottages around the lake had also been neglected for years and were in need of serious upgrading. Findley Lake fell asleep and remained this way until the late 1980s, when a renaissance began. The national trend of returning to America's small towns to discover a sense of place also began in Findley Lake in the 1990s. From one small antiques shop, operated by Nancy Small, on Main Street, to more than 25 retail businesses today, a dream of a few local people has really come true.

Brigadoon is a fanciful and delightful musical depicting life in a small Scottish village *c.* 1746. It was written by Alan Jay Lerner (book and lyrics) and Frederick Loewe (music). Cheryl Crawford first presented the show at the Ziegfeld Theatre in New York on March 13, 1947. Lerner's play was based on a Friedrich Gerstacker story about a mythical German village that fell under an evil, magical curse.

In Lerner's play, the Scottish village of Brigadoon became enchanted centuries ago. The community remained unchanging and invisible to the outside world except for one special day every 100 years, when it could be seen and visited by outsiders. Visitors might be allowed to stay, but if anyone ever left Brigadoon, the miracle would be broken—and that would be the end of them all!

Findley Lake in a way has followed the same path. It opened its doors to outside visitors in the late 1890s during the Lakeside Assembly years. Many of those visitors built cottages and stayed after the assembly closed for good in 1915. Nearly 100 years later, Main Street and the ensuing lakeside cottages started being fixed up and remodeled. Today, with the endless recreational and lodging possibilities of the area, it is easy to see why the Findley Lake region is considered to be a year-round resort area. Families come from all directions to enjoy the peacefulness and tranquility that the lake and the community offer.

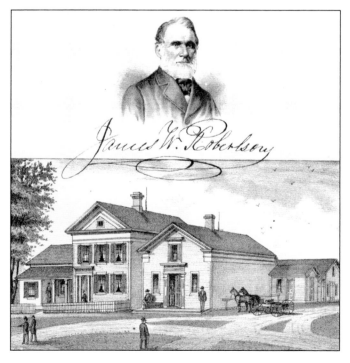

James W. Robertson operated one of the first businesses on Main Street in Findley Lake. This photograph shows his store and residence, which his wife continued to operate after his death in 1880. This property eventually became the Hotel Laurene, operated by the Swanson family. The hotel and a blacksmith shop nearby burned down in a fire along Main Street in 1919. Today, the fire hall and part of the parking lot on Main Street occupy this area. (Courtesy of Randy Boerst.)

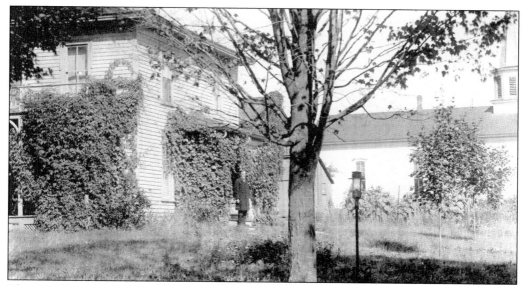

The First Baptist Church of Findley Lake was organized on June 17, 1865, under the pastoral care of Rev. Hollis S. Knowles. The first congregation consisted of 13 members. The church was built in April 1877 for the cost of $275. This church served the community of Findley Lake until the early 1920s, when the building was torn down and the property sold. The parsonage house for the church, pictured above, still stands today on Church Street and is the office building of Howard & Associates. (Courtesy of the Findley Lake and Mina Historical Society.)

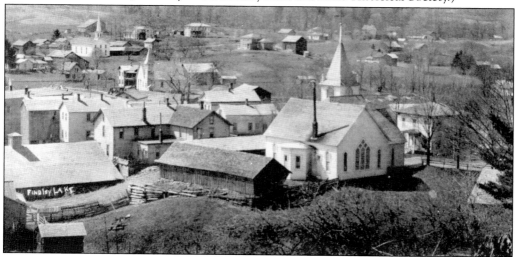

Findley Lake, like many small towns across America, had its choice of worship. Three churches occupied downtown Findley Lake: the United Brethren Church, the Methodist Episcopal Church, and the First Baptist Church of Findley Lake. The Methodist Episcopal Church was erected in 1859 at a cost of $650 and could hold a congregation of 300 people. The original Evangelical United Brethren Church on Main Street was also built in 1859. This church burned in a fire in 1947 and was rebuilt shortly after. The shell of it still stands today with a painting of Jesus on its side. All three of these churches had very high and ornately finished steeples, as this bird's-eye view of Findley Lake shows. (Courtesy of the Findley Lake and Mina Historical Society.)

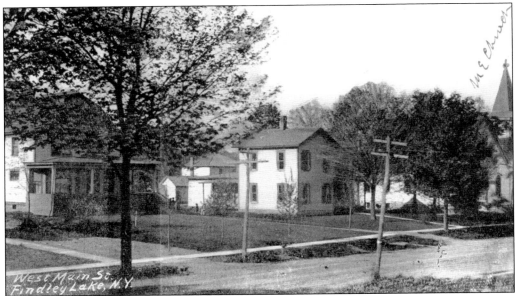

Main Street followed the path of old Native American trails to the head of the lake. It was all dirt until the early 1920s. This postcard shows West Main Street as it looked in the early 1900s. It has not changed all that much since then. Pictured are the homes of W.L. Nuttall and Grant Wilkinson. On the far right is the Methodist Episcopal Church. All of these buildings look the same today, minus the wooden sidewalks, but have been converted from private residences to businesses: the Blue Heron Inn, Candle Escents, and the federal post office. (Courtesy of Jerry Tenbuckel.)

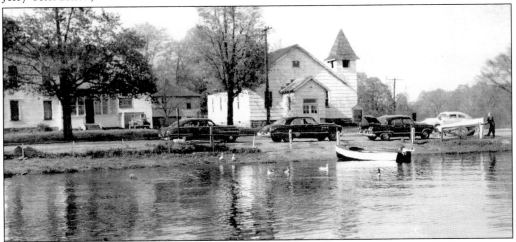

A dirt boat launch was located across the street from the mill buildings at the head of the lake. This was used when you could launch your boat by hand before the official launch was built at the other end of the lake across from the skating rink. Today, that boat launch is a private residence and is no longer open to the public. Art Cooper Jr. tells a story of how his father would launch their boat each summer. The Swartz Lumber Mill used very heavy and long boards that they would lay along the dirt launch and across Main Street and drag their logs over them. Art Cooper Sr. would use these same boards to take his boat in and out of the lake each season. (Courtesy of Jerry Tenbuckel.)

This was the Main Street home of Jim and Carrie Brookmire. Jim J. Brookmire operated several businesses along Main Street, including a carriage house and hardware store. He was also one of the original directors of the Lakeside Assembly in Findley Lake. As a boy, Art Cooper Jr. and his two sisters lived in this house during the winter months because it had a coal stove for heating, unlike their summer cottage on Shadyside Road. Notice the horse block in front of this house. This was used so that the ladies could ride their horses, sidesaddle of course. (Courtesy of John Swartz.)

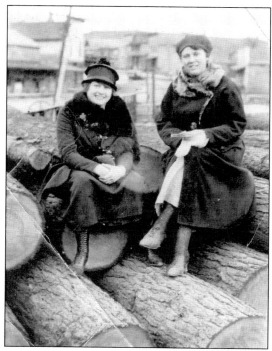

Katie Bradley (left) and Hazel Miles are "sitting on a Findley Lake beauty spot," as is written on the back of this photograph. Fresh-cut timber that was floated down Findley Lake each day by the workers at the lumbermill would constantly pile up at the outlet of the lake, ready to be made into lumber. This was very typical until the early 1940s, when the lumbermill finally closed for good. The Swartz Lumber Mill is pictured in the background. (Courtesy of the Findley Lake and Mina Historical Society.)

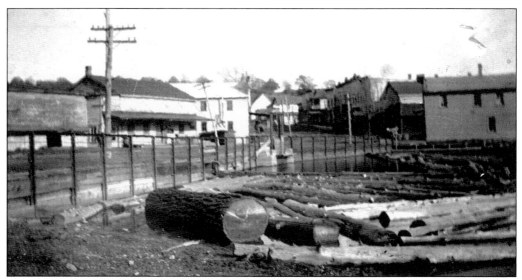

The Swartz family acquired the principal mill site from Ebenezer Skellie in 1892. This purchase included the ownership of the lake and the rights to control the flow and to keep the dam height at 10.5 feet. This deeded stipulation has always been conveyed to each successive owner since Alexander Findley left the mills and the lake to his two sons, Hugh and Carson, in 1832. As this photograph shows, the purposes of Findley Lake in the early days were transporting the fresh-cut timber to the lumbermills and producing power to operate the mills. Only after the mills closed down did Findley Lake become a recreational lake like it is today. (Courtesy of John Swartz.)

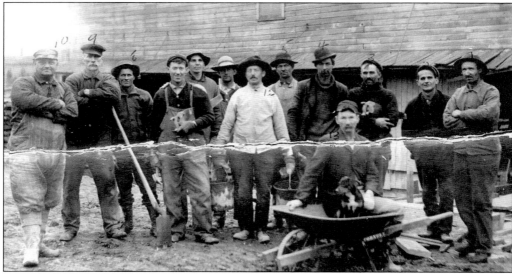

The men of the Swartz Lumber Mill are shown in front of mill in 1915. Included in the photograph are George Fox, Harry Gravink, Harry Ives, Leslie Smith, George Coe, George Giles, A.R. Smith, George Skellie, Louis Swartz, and Byron Bradley. Will Shum is sitting with the dog in the wheelbarrow. These men were also responsible for building many of the early cottages around Findley Lake, most of which still stand today. (Courtesy of the Findley Lake and Mina Historical Society.)

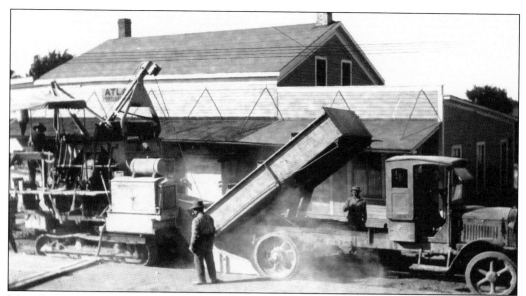

Main Street and Route 426 around Findley Lake were first paved in the 1920s. This photograph shows the highway construction crew working in front of the Swartz Lumber Mill. Only one side of the highway was paved for the new automobiles, which were becoming more and more prominent in the area. One side was left unpaved for the horse-and-buggy traffic that was still common for most of the village residents. (Courtesy of Randy Boerst.)

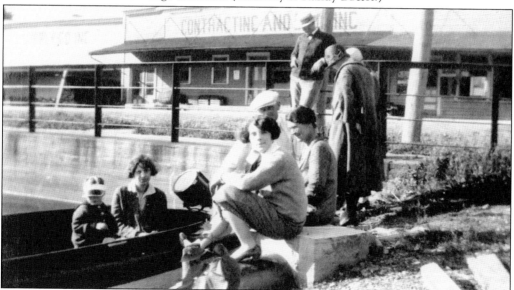

This area at the head of Findley Lake has always been a place where families and their children could swim, fish, and dock their boats. The cement wall and railings were completely reconstructed by the Swartz family in 1908 and lasted until the recent road improvement and new dam gates were installed in 1999. Relatives of the Swartz family are getting ready to take a leisurely Sunday boat ride around their lake in this photograph. This activity was as popular in the 1920s as it is today, even though the boats and people have changed over the years. (Courtesy of John Swartz.)

An end of an era is shown in this photograph, one of the last taken of the Swartz Lumber Mill, which was no longer in use, before it was sold. The mill, along with the lake rights, was sold to the newly formed Findley Lake Property Owners Association in 1948. Lawrence Swartz lacked a profitable use for the property and the lake but had a strong sentimental attachment to the lake and the people around it. He approached several businessmen of the time about forming an association to take ownership of the lake. The sale was closed for little more than the back taxes owed. The association was formed to promote the improvement and advancement of the Findley Lake area of the Town of Mina. The first board of directors included Clifton Howard, Fred Kinley, Arthur Cooper Sr., Arthur Cooper Jr., Lynn Rice, and Hal Meese Sr. The association tore down the mill in 1949 and still controls the lake to this day. (Courtesy of John Swartz.)

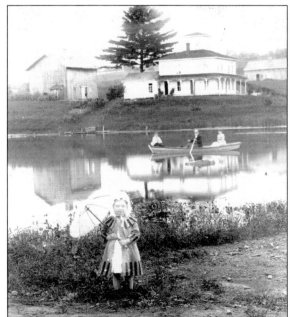

A very young smiling Lena (Gallup) Neckers holds an umbrella to keep the sun out of her face while her grandfather, Orlando Gallup, rows the family boat on a calm afternoon on Findley Lake. Gallup was a superintendent of a New York City steamship line and owned a number of properties around Findley Lake, including the house and farm in this photograph. He built the house, which still stands today, c. the 1880s. (Courtesy of Ken Neckers.)

Louis Swartz built this building in the 1920s to store and dry the fresh-cut lumber that was produced at the mill before being sold. This building has been the home to various businesses throughout the years. Al and Mary Smolk operated it as a feed mill for a period of time in the 1930s. It was also the home to the Findley Lake Grange League Federation (GLF) during the 1940s and 1950s. In the past 11 years, Jack and Sherri Hamilton have remodeled the building and now operate it as the Findley Lake Marine. (Courtesy of Randy Boerst.)

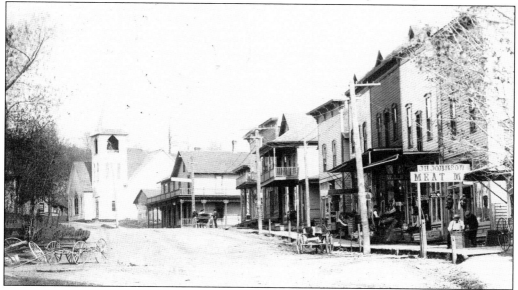

A view of Main Street looks east. By the 1890s, a family could purchase just about anything it needed in the prosperous village of Findley Lake. At this time, the thriving little hamlet contained a sawmill, a wagon works shop, a carding mill, a tannery, two harness shops, a blacksmith shop, a barbershop, two hotels, and a meat market. All these businesses served a generation of people who are now deceased. The back of this postcard is written to a businessman in Jacksonville, Florida, asking if he could sell these postcards in Florida because they portray a "typical old town." (Courtesy of Jerry Tenbuckel.)

Raven-Black harness oil was used for preserving carriage tops, boots, and shoes, all of which were important to people's lives in the early 20th century. This advertisement was for the "latest and best production of any kind on the market." The oil was sold at Freeman's Harness Shop on Main Street. (Courtesy of Jerry Tenbuckel.)

Barmore's Hardware sold everything from garden hoses to kitchen stoves. Pictured here are the owner-operators, Esler and Edna Barmore. Fine china calendar advertising plates sold at their store can still be found today, although they are very rare. This building, a church, a meat market, two general stores, a Grange hall, and Brookmire Hardware were lost in the devastating fire along South Main Street in the winter of 1912. This was the first of several fires that burned property on Main Street over the years. At the time of the 1912 fire, Findley Lake had a waterworks system, a large reservoir on the hill above the village with a pump in the lumbermill for emergencies. Had it not been for this and the town's "bucket brigade," the fire probably would have destroyed all the buildings on Main Street. (Courtesy of the Findley Lake and Mina Historical Society.)

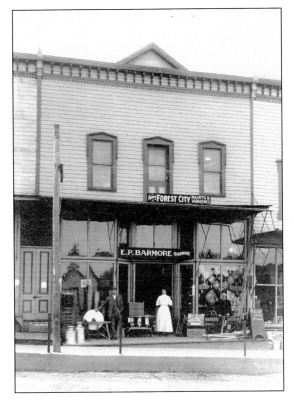

Furniture Repairing

Winston Odell ran a furniture-repair business on Main Street, which doubled as the post office during the 1920s, where he was also the postmaster. Antiques, as they are today, were very popular collector items during that time, and he sold these as well. Odell family members continue to operate an antiques shop in nearby Ripley, New York, today. Odell photographed many scenes and events around Findley Lake and made them into postcards. Some of the original negatives still survive today. Many of the photographs from those original early-1920s negatives are featured in this book. (Courtesy of Jerry Tenbuckel.)

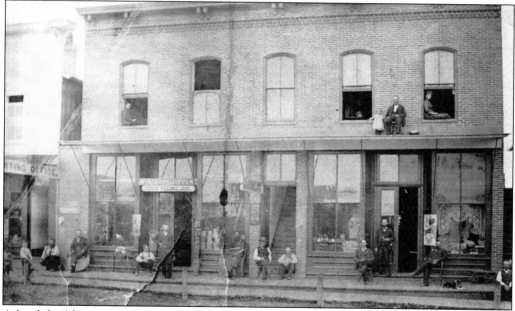

A brick building in Findley Lake? The sidewalk and storefronts on Main Street look the same today. The advertisement on the next page indicates that cigars are for sale on the Brick Block on Main Street. The *Findley Lake Breeze* of April 20, 1888, indicates that a man by the name of Pierce, from Wattsburg, Pennsylvania, opened a barbershop in the room over William Baker's store in Findley's Lake. He could be the same gentleman sitting on the roof in this photograph with his daughter. (Courtesy of the Findley Lake and Mina Historical Society.)

America's finest cigars sell for 5¢. Tansill's Punch sold at William Baker's, which advertised in the *Findley Lake Breeze* as having "the largest assortment of goods ever seen in this village. We carry more goods than many other stores combined." Not much about this brick building is known, but it probably partially burned down in one of the fires along Main Street and was replaced by the TenHagen building. (Courtesy of Randy Boerst.)

Will TenHagen was a direct descendant of Alexander Findley. He started cutting the hair of the area residents in 1903. He bought the building and shop, formally known as F.A. Dean, in 1909. F.A. Dean also cut hair and had a newspaper stand in this building. TenHagen cut hair on Main Street until his death in 1954. He was also the village undertaker and embalmed bodies in the adjacent part of his building. TenHagen was a very popular musician and played in many musical ensembles around the area, including playing trumpet at Gallup's Lake House for many of their festive productions. (Courtesy of John Swartz.)

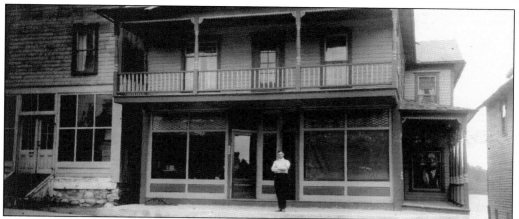

This is the original building where F.A. Dean and Will TenHagen operated their respective businesses on Main Street. TenHagen combined this building with the one on the left in the 1930s to house his expanding mortuary business. This created the new TenHagen building. TenHagen and his wife, Mary, lived in the living quarters above the shop in their later years. This building is still located on Main Street today. Having been remodeled in the early 1990s, it is now the home of Bud and Judy Noble's retail business called Wonderments: A Victorian Shop. (Courtesy of John Swartz.)

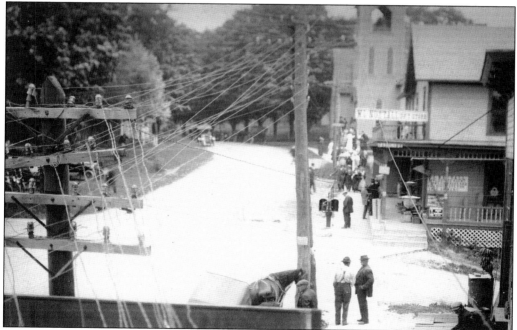

This photograph was taken on a Sunday afternoon on East Main Street. Sunday services have just ended, and the people are exiting the Evangelical United Brethren Church. They may even be headed to Gallup's Lake House for Sunday supper before returning home to do the daily chores. W.L. Nuttall rebuilt the general store on the corner that used to be the Lakeview Hotel. There was a large hall on the second floor where the Findley Lake Grange and the Fern Rebekah's Lodge held their organizational meetings at one time or another over the years. (Courtesy of Jay and Vicki Altman.)

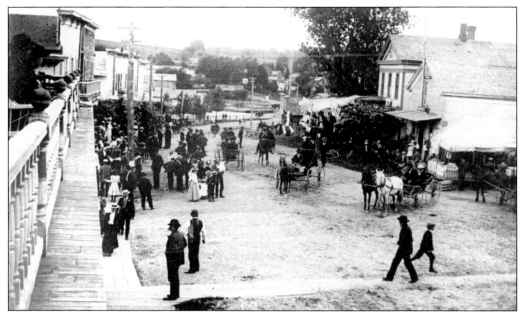

A view looking west down Main Street shows a prosperous, bustling village during the 1890s. This photograph was taken from the Lakeview Hotel on the corner of Main Street and Lake Street (Sunnyside Road today). The Hotel Laurene and a blacksmith shop are pictured on the right. Notice the wooden planks that were used for sidewalks, and they even extended out into the dirt street. (Courtesy of the Findley Lake and Mina Historical Society.)

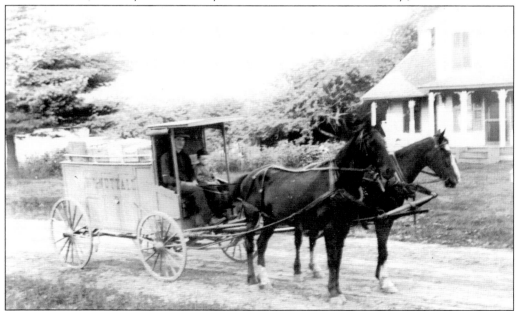

W.L. Nuttall's general store would make daily deliveries around the Findley Lake area to the various businesses and homeowners. This postcard shows a typical delivery day of peddling eggs and dry goods. The back of the postcard tells of the little boy in the delivery wagon, tired of yelling, "Eggs! Eggs!" all day long. (Courtesy of Jerry Tenbuckel.)

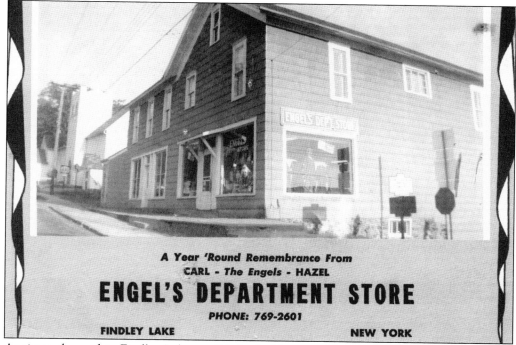

A Year 'Round Remembrance From
CARL - The Engels - HAZEL

ENGEL'S DEPARTMENT STORE

PHONE: 769-2601

FINDLEY LAKE NEW YORK

As times changed in Findley Lake, so did the buildings and businesses. They were remodeled and brought up to date. The W.L. Nuttall building, on the corner of Main and Lake Streets, had several different owners who operated different businesses out of it. Al and Mary Smolk operated the building as a grocery store and feed mill. Archie Post and William Edwards operated it as a general store and feed mill. Carl and Hazel Engel operated it as a department store. Eventually, as people started to do their shopping in bigger cities, the business closed up, and the building was vacant for a number of years before it was torn down in the 1980s. The lot is still empty today. (Courtesy of the Findley Lake and Mina Historical Society.)

The Brookmire Hardware wagon is shown making deliveries to the village people in the Findley Lake area. The Brookmire Hardware building was one of the seven buildings that burned in the fire of 1912 on Main Street. After the fire, J.J. Brookmire went into business with Nuttall. This photograph also shows the northeast corner of Main and Lake Streets. One of the first buildings on the lot where the Findley Lake Trading Company is today was a millinery, which designed, produced, and sold women's hats. (Courtesy of John Swartz.)

W.L. Nuttall built this garage to house his Ford dealership in 1916. At one time, he operated Ford dealerships in Findley Lake, Sherman, and Panama, New York. While supervisor of the state department of public works, he secured two appropriations to dredge Findley Lake. This was done between 1903 and 1912 to rid the lake of all the tree stumps. The Model T was becoming more popular in the area, and the garage saw a booming business in the 1920s. As the automobile became more reliable, repairs became less frequent. The service garage and dealership closed in 1933, at the start of the Great Depression, and sat vacant for a number of years. (Courtesy of John Swartz.)

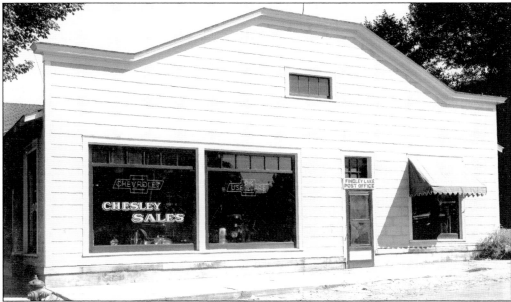

Roy Chesley, who worked as a clerk for W.L. Nuttall at his general store as a boy, opened up a Chevrolet garage and dealership in this building in the 1940s. He ran this dealership until 1956, when it became Proctor and Mathews Chevrolet. The post office also operated out of this building for a number of years, with Louie Munger Hitchcock serving as the postmaster. (Courtesy of the Findley Lake and Mina Historical Society.)

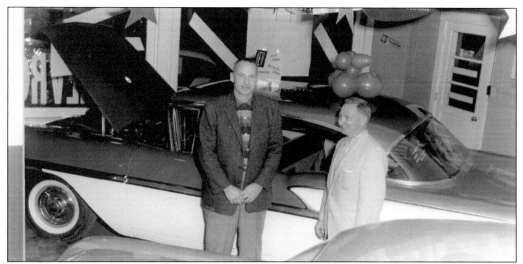

Rex Proctor (left) and Alva Mathews are shown inside their Chevrolet dealership at the unveiling of several of the 17 new Chevrolet automobiles for the 1958 model year. Proctor bought out Mathews one year later and renamed the dealership Proctor's Chevrolet. He operated this business, as well as a car wash and gas station across the street in later years, until he retired in 1985. The building has since been remodeled and is now the home of the Findley Lake Trading Company, owned by Ken and Linda Wayne. (Courtesy of Rex and Joan Proctor.)

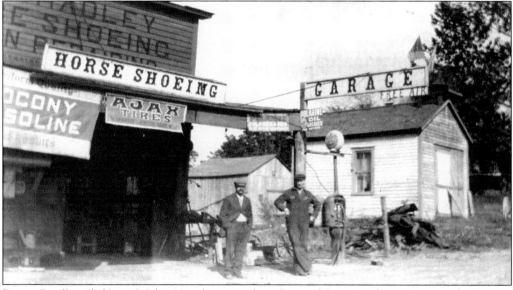

Byron Bradley (left) and Silas Himilein stand in front of B.H. Bradley's. Because he had to adapt to the changing market, Bradley offered the traditional horseshoeing and buggy repair along with the totally new automobile service: gas, tires, air, and repairs. Before Bradley's had its business on this lot, there used to be an opera house where the latest presentations were held and renowned speakers would lecture. This building and business stayed in the Bradley family until the early 1980s, when it eventually became unprofitable and too hard to keep open. Katie Bradley was still pumping gas here well into her 80s. (Courtesy of the Findley Lake and Mina Historical Society.)

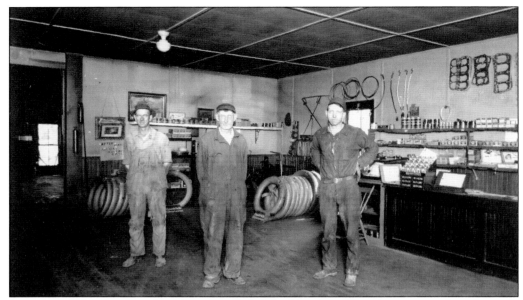

Stacks of Model T tires and other new automobile parts waiting to be put to use line the walls inside Bradley's garage in the 1920s. A sign on the wall tells all the customers that "after May all gas must be in cash." Notice the two Civil War swords crisscrossed on the wall in the back corner. Perhaps they hung there in case of a rowdy customer. (Courtesy of the Findley Lake and Mina Historical Society.)

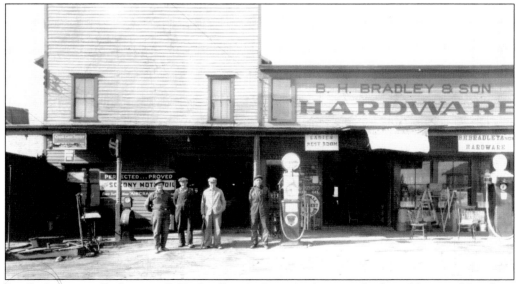

Bradley's eventually became B.H. Bradley & Son Hardware with the addition of Bradley's son Rollie. The business continued to operate as a garage and service station, while selling additional hardware items. Eventually, Rollie's son George took over the business and ran it as Bradley's Fleetwing. At the time this photograph was taken, dances were held on the second floor as entertainment on special weekends. The building has recently been remodeled and is now the home of Legacy Designs, which sells furniture and home-decorating items on both floors of the building. (Courtesy of the Findley Lake and Mina Historical Society.)

Findley Lake was beginning to change. Main Street was paved on both sides of the street, and cement sidewalks replaced the wooden planks. The changes did not stop there, as businesses were switching hands and offering different merchandise for sale. By the late 1920s, the following businesses occupied Main Street: Giles Garage and Restaurant, Winston Odell Antiques, John Peterson's hardware store, the federal post office, Jessie Hurlburt's Red and White Store, W.L. TenHagen Mortician and Barbershop, M.C. Wilkinson Confectionery, G. Titus Meat Market, Findley Lake Department Store, Nuttall's Ford Garage, B.H. Bradley & Son Hardware, H.C. Gaffney's Lunch Room, and L.F. Swartz Feed Mill and Lumberyard. (Courtesy of Randy Boerst.)

Johnny Peterson holds Richard Odell in front of Winston Odell's store near the flume. Peterson's Tinsmith and Hardware is on the left in this photograph. Peterson opened and operated his business after Brookmire Hardware burned down in 1912 until 1934, when he suddenly passed away. The Odell building had several businesses operate out of it over the years, including Wright's Grocery Store and Cooper's Country Store. Boats used to be able to pull up alongside the dock and go inside the store. The building has since been torn down to make room for the state park that occupies the lot today. (Courtesy of Randy Boerst.)

The Findley Lake Fire Department was formed in 1932 and incorporated in 1947. It was formally started when Rollie Bradley rebuilt an old car into the first fire truck. The first fire chiefs were Harry Raymond, Rollie Bradley, Larry Swartz, and Don Rothenburger. This 1951 photograph shows the newly built fire truck garage. The dining hall and meeting room was not added until an expansion of the building occurred in 1961. (Courtesy of the Findley Lake and Mina Historical Society.)

Nettie and Minford Peterson sit on the anchor that now rests at the head of Findley Lake. The Dunlap family donated the anchor to the Findley Lake Property Owners Association in 1993. The anchor originally came from the *Mauteenee,* a cargo ship that operated on the Great Lakes. In the early 1900s, George H. Fox purchased the anchor and had it moved by horse-drawn wagon to his property on North Road. Many years later, the Harry Dunlap family purchased that property. The Findley Lake Chamber of Commerce was formed in 1994, and it adopted this anchor as its logo. (Courtesy of the Findley Lake and Mina Historical Society.)

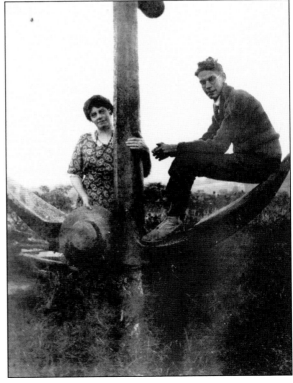

Bert Giles originally built this building as an automobile service garage. He tore down the old barn that used to occupy the lot and used the lumber to build the new building. He serviced Dr. Finn's Model T quite often, as he lived across the street in the old Nuttall home, where he also had his doctor's office. Mrs. Smith eventually transformed this building into a restaurant. Gilbert and Maudie Cray operated it as Maudie's in the 1960s. In the 1970s, Bud and Judy Noble used it as a pizza shop called B.J.'s. The building has been home to several owners and restaurants since. Today, it has been remodeled and operates as Thelma Lynn's Country Kitchen. (Courtesy of the Findley Lake and Mina Historical Society.)

This photograph of the Route 426 and School Street intersection shows Eastview, the home of Bertha TerHaar, in the background. Ora Pitt originally built this house in 1884. The Nobles restored this treasure in 1974 and operated it as the Curly Maple Restaurant. Although the business has changed ownership, it is still serving homemade, old-fashioned dinners and desserts today. Alexander Knowles lived in the house shown at the far right in this photograph. (Courtesy of Randy Boerst.)

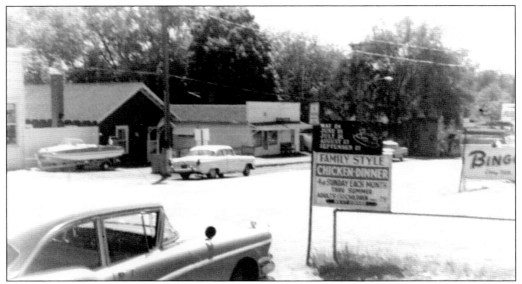

A 1950s view of Main Street looks south toward the lake. Commerce in Findley Lake was starting to wind down. As automobiles became more affordable, people were increasingly traveling to bigger cities to shop and dine. The Findley Lake Fire Department offered family-style dinners once a month on Sundays and bingo every Thursday evening during the summer months as fundraisers. (Courtesy of the Findley Lake and Mina Historical Society.)

This 1980s photograph of the Tony Litz property and the Bradley building on Main Street shows Findley Lake in shambles. The thriving businesses are closed, and the once beautiful buildings are left vacant. The national trend of returning to America's small towns to discover a sense of place started to occur in Findley Lake in the early 1990s. The opening of one antiques shop, operated by Nancy Small, started a renaissance on Main Street. More than 25 businesses are open today. It is easy to see why the dream of a few local people has come true, but we can never forget what it looked like just a short time ago. The renaissance needs to continue. (Courtesy of Jay and Vicki Altman.)

Two

YOU LIVE ON AN ISLAND?

Before Alexander Findley built his dam site and mill at the head of the lake, the area was known far and wide by Native American tribes as two small ponds with an island in the middle of each.

It is almost certain, historically speaking, that the Eriez Indians built a narrow causeway from what is now known as the Lagoon Island to the Big Island. In the process, they actually made the Lagoon Island as a protected land terminus by digging a moat around a projection of the shore. The purpose of this was protection and the development of a defense system for the much larger Big Island. Remnants of similar fortification techniques have been found at nearby Cassadaga Lake and elsewhere.

Legend has it that in 1753, Maj. George Washington crossed through Findley Lake. He had orders to go to Fort Niagara, which was the headquarters of the French army. It is well documented that he visited Fort LeBoeuf before starting out for Fort Niagara, crossing the northern edge of Mina Township while en route. As he and his companion, Christopher Gist, neared the upper end of Chautauqua Lake, inclement weather and hostility of the Native Americans convinced him that it was foolhardy to continue any farther. They turned back and found themselves that night at the shores of a small woodland lake with an island in the middle. They immediately built a small, crude raft in the winter storm and set out for refuge of the island. The heavy thicket of hemlock trees on the island would provide the much-needed safety from both the local natives and the inclement weather. Washington and Gist camped on the island for three days. In that short time, ice had formed on the lake, so they walked back to the mainland to resume their journey to Fort LeBoeuf. As Findley Lake is the only body of water in Chautauqua County with a wooded island, it must have been Findley Lake where George Washington and Christopher Gist spent those three days if the legend is true.

Findley, the Jewel of the Lakes

You know Erie, and Michigan, and Superior and Huron, Ontario, and Chautauqua and the Great Salt Lake. But do you recall the most famous lake of them all?

Findley, the jewel of the lakes has a lot of fun things to do! And if you ever saw it, you could even do those things too.

All of the people who stop here used to laugh and call it Findley's puddle; they never knew the joys of snipe hunting in a big huddle.

Then one snowy New Years Eve, the skiers came to say: "Findley, with your Island-tree so bright, won't you take a hay ride tonight?"

Then how the families partied as they shouted out with glee, "Findley, the jewel of the lakes, you'll go down in history."

You know Burtons and Bolts and Steinbrenners and Conners, McDermotts and Stohrs and McCunes and Kerns, but do you recall the most partying family of all?

Ferriers with their fireworks and Olympic games have a cupboard full of brass monkeys and if you ever tried them you could even act real "funky."

All of the Findley Lakers decorate their boats in July; and when it rains on French Creek they can even survive raft rides.

Then on summer mornings, Robert comes to say: "Come on over for a Pancake Bref'fast, Bochi-ball, songs and bonfires."

Then how their friends did love them as they shouted out with glee, "Christie and Bob and your family, you'll go down in history."

There were lobster bakes and golfing, and bike riding to the Peak, canoe races and corn roasts, and dancing contests till three. But do you recall the most famous winters of all?

Late night tubing on the J-bar had Ferrier's blazer stuck in the snow, but when we all were snowbound, his was the only car that could go.

All of the snow skiing and waterskiing, made us grow to love Findley Lake, we never minded the clean up, burn those leaves and grab a rake.

Findley . . . with your island so bright, won't you guide our sleigh tonight. Oh how the families love it, as they sing and shout with glee, "Findley the jewel of the Lakes, you'll go down in history."

—Composed by Lynn Stohr and Jeanette McDermott
to the tune of "Rudolph the Red-Nosed Reindeer."

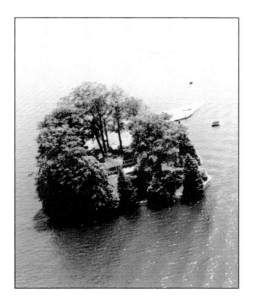

The Big Island property consists of one acre of land that is accessible only by boat. It has been described by Bob Ferrier as a "good golf drive away from the island shore house." You would have to spend a whole day on this beautiful natural spot to appreciate this sanctuary—to let the mind wander as Findley's waters flow, with memories of days gone by, to give your heart a glow. The opportunity to let the worries of time pass you by makes this the most special place of all. (Courtesy of Bob and Christie Ferrier.)

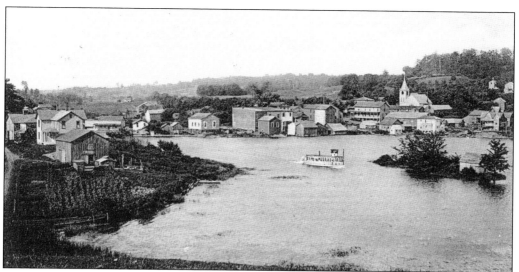

Various owners, from Mr. Hoffman to Donald LaRose, have owned the small island near the village up until 1940s. The small island has always been used for picnics and corn roasts by various families over the years. Other than a small shedlike building, as shown in this photograph, it has never been developed. The Findley Lake Property Owners Association is the current owner of this island, having purchased it from Donald LaRose in September 1949 for $1. Years of boat traffic have taken its toll on the island and have caused a great deal of erosion. The property owners are in the process of restoring it before it completely washes away forever. (Courtesy of Randy Boerst.)

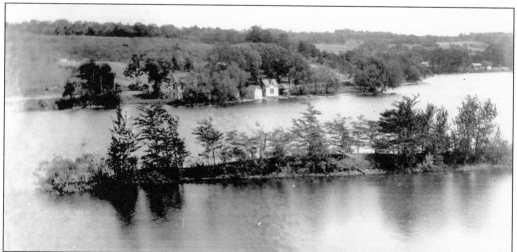

The small island was once larger and heavily wooded, as this photograph indicates. In the late 1800s and early 1900s, fireworks used to light up the village every Fourth of July as they were set off from this island. It was also very popular for young Findley Lake children to swim out and play on it. Minford Peterson and Kay Nuttall once ran telephone wire with sinkers tied to it out to the island. They then took a homemade telephone to the island and put another telephone in Nuttall's bedroom. Thus, they established telephone communications from the small island to the mainland for the only time in history. It probably did not last very long. (Courtesy of Randy Boerst.)

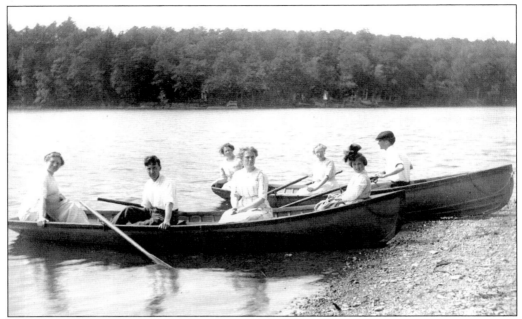

It was always a popular activity for young couples and families to row out to and have picnic and corn roasts on the Big Island. Les Hulburt, who was written up in *Who's Who in Indian Artifacts,* found many of his arrowheads and other early Native American artifacts on the Big Island. (Courtesy of John Swartz.)

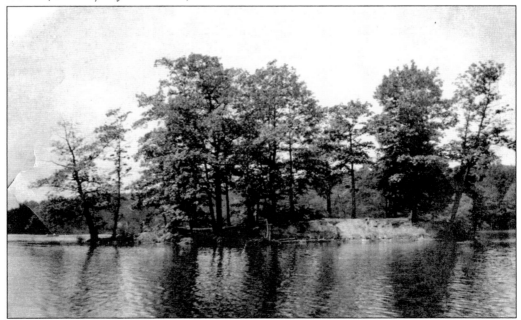

Charles A. Ives, an air brake engineer at General Electric in Erie, Pennsylvania, purchased the Big Island at a tax sale from the state of New York for $300 in 1933. Ives and his family used the island for camping and picnicking, as numerous families had done for years before he purchased it. (Courtesy of the Findley Lake and Mina Historical Society.)

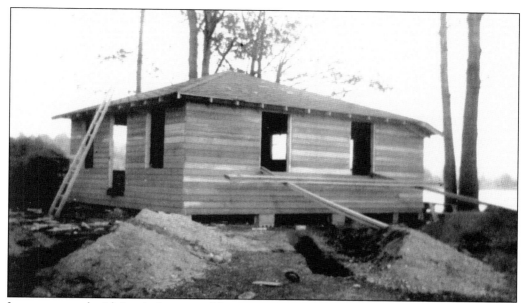

Ives contracted with Louis Swartz and his crew to construct the first building on the island in 1935. It was 20 by 20 feet with no electricity or running water. All of the materials and tools had to be hauled out to the island by boat. (Courtesy of Bob and Christie Ferrier.)

The first building on the island is shown completed and boarded up before the final stages of winter set in. Construction inside the house was set to start in the spring of 1936 or as soon as the ice melted. (Courtesy of Bob and Christie Ferrier.)

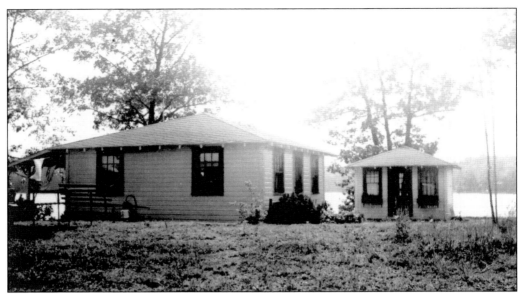

In the spring of 1936, after a hard winter, the Swartz Lumber Mill built a second building on the island. It was 12 by 12 feet, just big enough to hold two sets of bunk beds with built-in dressers that are still in place today. A hand-driven water well was also dug during the construction. Imagine traveling back and forth by boat to transport all the construction equipment and supplies. (Courtesy of Bob and Christie Ferrier.)

After the bunkhouse construction was completed, the main building was partitioned off into four rooms. A brand-new propane stove, pictured here, was installed, and oil lamps were hung around the cottage for light. (Courtesy of Bob and Christie Ferrier.)

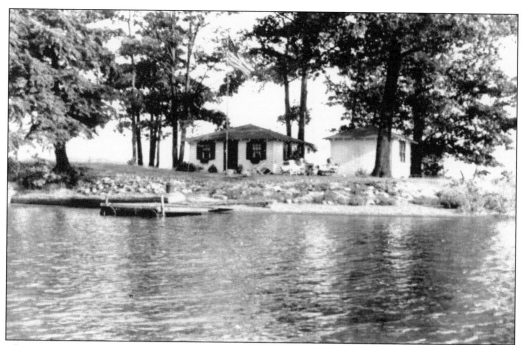

These two photographs show the island becoming the showpiece of Findley Lake. New docks were built and shutters were added to make it a little piece of paradise for the Ives family. An American flag was also flown for the first time on the Big Island. Landscaping was started, and trees and flowers were planted everywhere. This was the beginning of grander things to come for Findley Lake's historic natural landmark. (Courtesy of Bob and Christie Ferrier.)

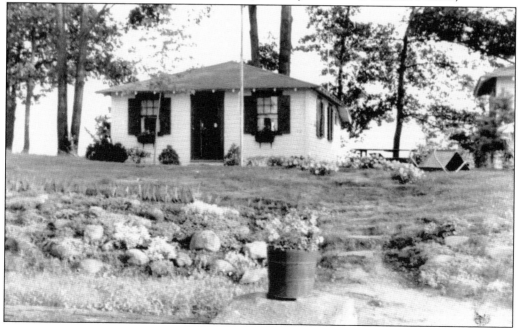

In 1938, Charles Ives purchased a lot on the mainland across from the newly formed Methodist church camp on Little Corry Road. He then proceeded to build the big boathouse shown in this photograph so he would have a place to store his boats for the constant traveling back and forth from the island. This boathouse would eventually become the island shore house. (Courtesy of Bob and Christie Ferrier.)

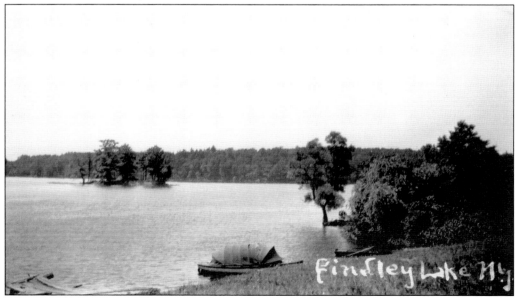

After her husband passed away in 1943, Mrs. Charles Ives sold both the island and the boathouse properties to Dayton E. White. White worked for International Business Machines (IBM) at the time. His first order of business was adding a fireplace to the main building on the island for heating purposes. (Courtesy of Randy Boerst.)

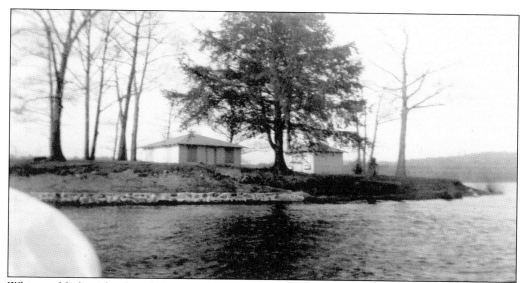

White sold the island and shore properties after only two years to Gordon T. Turnball and Edward Ismond, who were both from Cleveland, Ohio. Turnball owned an architectural firm, and Ismond owned the Hatfield Electric Company. With the help of their respective businesses, major renovations of both the island and shore properties would soon begin. (Courtesy of Art and Mary Cooper.)

Turnball is pictured standing on the front lawn of the Algonquin Lodge. He loved Findley Lake and the people who lived there. Over the next seven years, he would donate a lot of money to the development of the Findley Lake Property Owners Association and the maintenance of Findley Lake itself. (Courtesy of Art and Mary Cooper.)

Turnball and Ismond took advantage of their respective businesses to update and install the necessities of modern living to both the island and the shore properties. Their first project was enlarging the boathouse by adding two boat bays and a livable cottage on top of the bays. This would provide the much-needed guestrooms for entertaining the many company clients who would visit Findley Lake throughout the summer months. The new shore house was also decorated in the same fashion as the island cottage at this time. (Courtesy of the Meese family.)

The island cottage was the next to be completely renovated. First, the owners added a bathroom and master bedroom, complete with its own fireplace, to the bunkhouse. Next, they joined the newly expanded bunkhouse and the existing main cottage with a large 16 by 16 foot Pullman-type kitchen. This was done for the large-scale entertaining they expected to be doing each summer. At this time, electric and telephone lines were laid under the bed of Findley Lake to give the new island cottage these services for the first time in its history. To complete the modernization of the property, indoor plumbing was installed, and a new water well was drilled. (Courtesy of Bob and Christie Ferrier.)

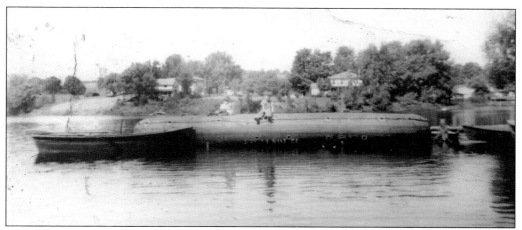

The modernization of the island cottage was completed in 1948 by replacing all the windows with new bay windows and hanging knotty-pine paneling on all the walls and ceilings. Brand-new furniture was then transported across the lake to complete the decorated interior. A stone patio was laid between the two combined buildings in front of the new kitchen. The big raft shown in this photograph was used to transport many of the materials that were used to remodel the island cottage. Dr. John J. Patti, from Sherman, New York, bought this raft after the project was completed and used it as a swimming pool for his three girls, Verti Mae, Suzanne, and Cynthia. (Courtesy of Art and Mary Cooper.)

The large narrow causeway (sand bar) to the Lagoon Island was starting to impair the increasing motorboat traffic on the lake. Because most of this causeway lay just a few feet under the water, motorboat props would either get stuck or damaged on it. In the summer of 1948, Ismond and Turnball began dredging this causeway and using it as fill for the new cement break wall that was constructed around the island to prevent further erosion. During this process, they enlarged the island by 115 feet along the largest part of the causeway connected to the island. This was also cemented to form a break wall. This then created the horseshoe shape that the island is today. (Courtesy of Randy Boerst.)

A lawsuit was filed and waged against Ismond and Turnball for expanding the island by 115 feet without permission from the newly formed Findley Lake Property Owners Association, which now owned and controlled the lake. After many court battles and a year's time in negotiating, the association dropped the lawsuit in exchange for a significant donation to the association by the island owners. Part of the agreement also included installing lights around the newly formed horseshoe section. This was insisted upon to prevent unexpected motorboat operators from running into it at night. (Courtesy of Art and Mary Cooper.)

In 1955, the Cleveland Electric Company bought out Ismond Power and Light. This spelled the end of the glamorous parties and client entertaining on the island. Both the shore house and the island cottage were closed up and used very sparingly over the next 15 years. (Courtesy of Bob and Christie Ferrier.)

By 1975, after a series of partnerships and renting out the island property each summer, Bob and Christie Ferrier and their five children became owners of both properties. Years of neglect had taken its toll on the properties. They began immediately fixing up and remodeling both properties, starting with the shore house. A major addition was added, which included a large dormitory-style bedroom and new bathroom upstairs. A laundry and mud room were added downstairs, and the interior was completely redecorated and winterized for the first time. The Ferriers would use this shore house all winter long with their friends after skiing throughout the day at Peek'n Peak. (Courtesy of Bob and Christie Ferrier.)

The island property was next for a total renovation. It was completely redecorated inside and out and landscaped throughout. The project required hauling over 130 tons of bricks and materials from the shore to the island to accomplish this. By the summer of 1985, the island was again a showplace. For the next 10 years, this would be the party spot on Findley Lake. In a sense, the Ferriers started the renaissance of fixing, remodeling, and expanding the many lakefront cottages on Findley Lake. Today, there are very few lakefront properties that are in need of repair. (Courtesy of Bob and Christie Ferrier.)

Even while the Ferriers were remodeling, they still had time for fun and wild events: island Olympics, huge fireworks displays, teeing golf balls off the island, lobster bakes, barbecues, Sunday pancake breakfasts, and lots of partying. It was nothing to have over 100 people on the island at one time. These became annual summer events, which the Ferriers held for the twenty years that they owned the island. (Courtesy of Bob and Christie Ferrier.)

When the weather turned ugly, everybody packed up and went inside the island cottage to watch movies and eat pizza, and, of course, someone always ran out to get ice cream. During the winter months, the events moved to the shore house. The Ferrier family used the shore property all winter long while skiing at Peek'n Peak. Both island properties are still privately owned today. (Courtesy of Bob and Christie Ferrier.)

Capt. D.T. Lane was the first person to build a cottage on the Lagoon Island, c. 1880. The cottage is decked out with university pennants in this early-1900s photograph. It must have taken Lane a long time to build the break wall from individual tree limbs. This cottage still stands in its original condition, except for indoor plumbing and electricity, which was added in the 1920s. (Courtesy of John and Sue Shifler.)

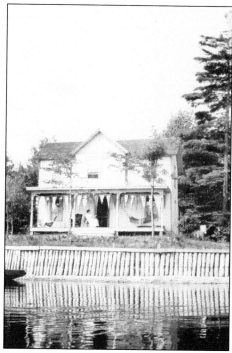

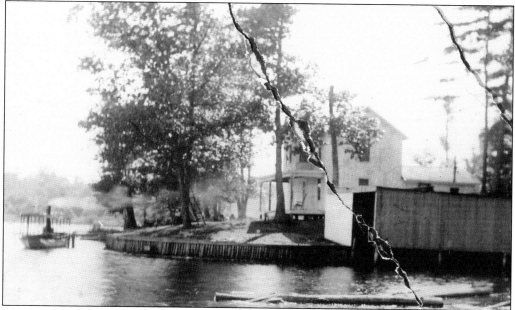

This site appealed to Captain Lane because of its natural channel around the island, which was made by Native Americans a long time before he arrived. When Lane would steer his steamboat up to this boathouse, he would have a terrible time leaving again because there was no reverse. To remedy this, he dredged the channel around his cottage again. This enabled him to dock his steamboat and then pull forward when leaving and go around the island and out onto the lake to pick up the waiting passengers. (Courtesy of John and Sue Shifler.)

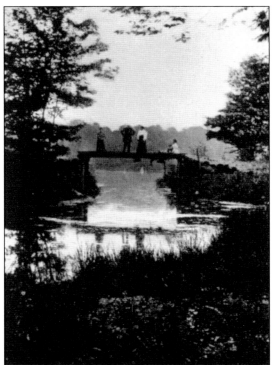

Members of the Lane family observe the scenic natural beauty of the lagoon area from the bridge that connects the Lagoon Island with the mainland. At the time of this photograph, it was just a footbridge. The height was required so Captain Lane could steer his steamboat underneath the bridge when traveling out into the lake. (Courtesy of Jerry Tenbuckel.)

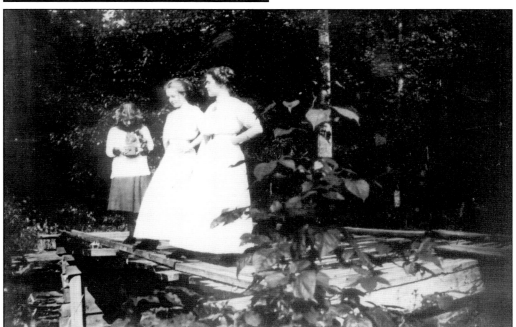

Young ladies from the Lane family pose on the Lagoon Island footbridge in their new dresses. This bridge is still there today, although it is not as high and is made of steel reinforcements for automobile traffic. The bridge provides the four cottage owners and their guests access to their respective properties. (Courtesy of John and Sue Shifler.)

Three

THE LAKESIDE ASSEMBLY YEARS

The Lakeside Assembly operated on the western shore of Findley Lake from 1895 to 1915. Dr. F.E. Lilley and Rev. C.G. Langdon took advantage of the success that the Chautauqua Assembly had experienced for the previous 21 years on Chautauqua Lake. They decided that another assembly could be successful in the same county. The Tent Chautauqua circuit was also popular at this time, as it was operating in more than 8,500 small towns and communities across the United States and Canada. Although these Chautauquas were not connected and were operating beyond the control of the original Chautauqua, they helped expand the cultural experience into these rural communities.

The Lakeside Assembly was not any different than the mother Chautauqua. As with most of the traveling Chautauquas, they were attracted to towns that had lakes or bodies of water nearby. Many of the same speakers used the lecture platform to advocate for prohibition, suffrage, and a variety of other political agendas. Thousands of people from nearby cities flocked to Findley Lake as the Lakeside Assembly advertised opportunities for education, entertainment, culture, and inspiration. The platform programs informed the attendees of the current issues of the day and a variety of other topics for individual betterment, including various religious beliefs.

The season lasted for four weeks in August throughout the 20 years of its existence. Admission was 10¢ a day or $1.50 for a season pass the first year. By 1915, the price was 25¢ a day or $3 for a season pass. After a successful first season, a stock company was formed and a board of directors was elected to take charge of the assembly in the place of the partnership management of the first season. It was determined that a group of capable, progressive businessmen were needed to continue the success of the assembly operations. The first board of directors included Dr. F.E. Lilley, J.J. Brookmire, Volney White, J.A. Hill, Ebenezer Skellie, Rev. R.J. White, Dellmer Beebe, Louis Swartz, Rev. C.G. Langdon, Walter Sperry, and A.F. Stanley.

The Lakeside Assembly continued to grow each successive year, and cottages were built on both sides of the lake. Findley Lake was becoming a center of culture, religious sentiment, and temperance. Crowds of tourist would pack into a barnlike auditorium, which was built on a hillside on the assembly grounds, to hear the most eminent speakers, gifted musicians, and performers of the day. They would sit on wooden hemlock benches, accommodating

approximately 2,000 people, which started at street level and continued up the hill. This provided the best view of the stage below.

Daily programs included children's instruction and entertainment, Shakespearean plays and operas, adult classes in various subjects, Bible lessons, lectures, entertainment, musical performances, and Chautauqua Literary and Scientific Circle discussions. There were also physical activities that included picnicking, swimming, boating, fishing, croquet, basketball, baseball, lawn tennis, and even hunting (allowed in season for duck, partridge, and woodcock).

31	49	LAKESIDE ASSEMBLY	50	
1	5	SEASON TICKET	52	2
3	53	(Non-transferable) 1914	54	4
5	55	1914	56	6
7	57	$3.00 No. 670	58	8
9	59		60	10
11	61	This Ticket to the grounds entitles the purchaser, whose name appears below in his or her own handwriting, to ingress or egress at pleasure, and must	62	12
13	63	be punched on entering the grounds or it will not be good for exit, and must be punched on leaving	64	14
15	65	the grounds, or it will not be good for entrance, and if presented by any other person will be taken up.	66	16
17	67	The purchaser of this ticket, in consideration of its issue to him or her agrees to obey all rules and	68	18
19	69	regulations of said Institution, and in case of violation of said rules and regulations, forfeits all rights	70	20
21	71	granted by this Ticket. In which case this Ticket may be taken up and cancelled upon the order of the Board of Directors.	72	22
23	73	Lakeside Assembly	74	24
25	75	J. J. Brookmire Chairman, Board	76	26
27	77	The Assembly is not responsible for Lost Tickets.	78	28
29	79	The loss of this one may cost you $3.00 or the price of a Season Ticket.	80	30
31	81		82	32
33	83	THIS TICKET MUST BE SHOWN WHEN ENTERING THE AUDITORIUM or at any	84	34
35	85	time upon demand of any Officer of the Assembly.	86	36
37	87	This ticket is good for entrance or exit on Sunday.	88	38
39	89	See Law and Gate Tariff on back of this ticket.	90	40
41	91		92	42
43	93		94	44
45	95		96	46
47	97		98	48
	99	(Purchaser Sign here in Ink)	100	

Either a season ticket or day pass had to be purchased to enter the assembly grounds and participate in the programs offered. This ticket or pass also had to be shown upon exiting the assembly grounds. This provided not only daily attendance counts and a way of controlling the crowds but also much-needed revenue that kept the programming alive over the years. (Courtesy of Jerry Tenbuckel.)

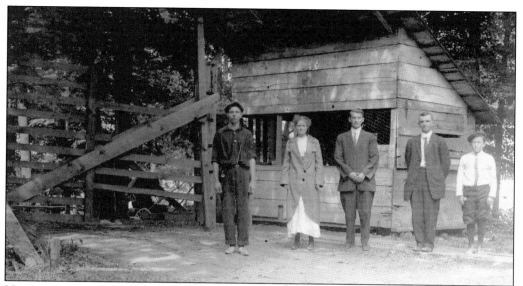

Upon arriving at the Lakeside Assembly grounds by horse and buggy or walking, the first order of business was purchasing either an all-day ticket or a season pass. Pictured here is the large wooden control gate and ticket booth at the entrance to the assembly grounds. These five young people were ticket attendants and information providers. (Courtesy of the Findley Lake and Mina Historical Society.)

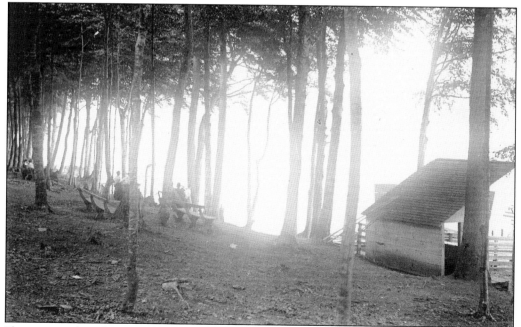

If your arrival to the assembly grounds was by one of the several steamboats that operated on the lake, this is where you would have entered the grounds after departing from the boat. This is also where you boarded the steamboat again when leaving. In between programs and activities, sitting on these benches and watching the peacefulness of the lake was also popular. (Courtesy of John C. Peterson.)

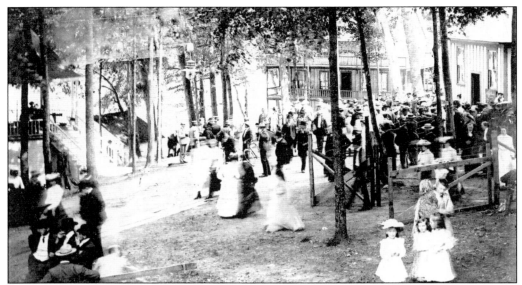

Opening day in August 1895 was filled with enormous crowds. This photograph shows people exiting the auditorium after an afternoon performance. Excellent advertising of the new attraction in Findley Lake in the neighboring communities stirred up considerable interest. People came in wagons, buggies, by horseback, and on foot from far and near. W.L. Nuttall tells the story of selling out of all cigars, candy, canned goods, and practically everything that was edible at his general store on Main Street that opening day. (Courtesy of Randy Boerst.)

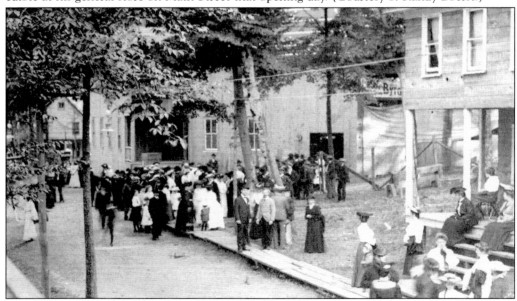

The assembly grounds were too small for the crowds, as indicated by this photograph, which shows the activity at the opening-day celebration. The only entertainment scheduled that first day was a speech and some foot races of different types. Many people took advantage of the *Lula Belle*, a steamboat operated by William Breckeridge. Brookmire and Nuttall gave out free boat ride tickets if you purchased $3 worth of merchandise at their general store. (Courtesy of the Findley Lake and Mina Historical Society.)

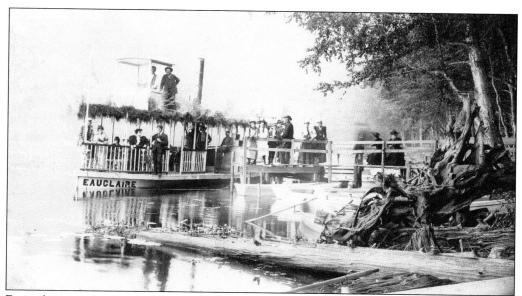

Even the steamboats were decorated to transport the passengers to and from the assembly grounds. Several steamboats, such as the *Eauclaire*, owned and operated by Louis and Phillip Swartz, would travel up and down the lake about six times a day, taking passengers to and from the grounds and also on excursions around the entire lake. The price for each steamboat ride was 5¢. Notice how undeveloped and natural the shoreline was during this period. (Courtesy of John C. Peterson.)

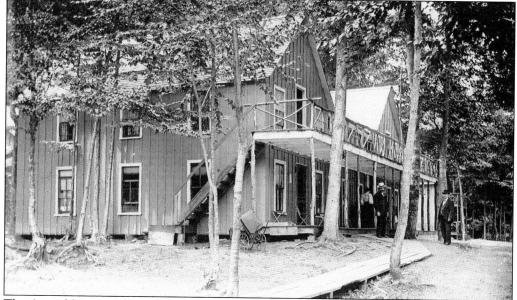

The Assembly House (Hotel) on the assembly grounds was one of several accommodations for the many overnight guests. Prices were advertised at $5 per week or $1 per day with clean beds and a good menu for eating arrangements. Horses were cared for and fed grain and hay for an additional 25¢ a day. The horses were kept in back of the hotel on top of the hill. (Courtesy of the Findley Lake and Mina Historical Society.)

By the second year, the road to the assembly grounds had been improved and was described as "one of the most picturesque imaginable, winding along the lake shore as it does." This view is traveling from the village to the assembly grounds. (Courtesy of Randy Boerst.)

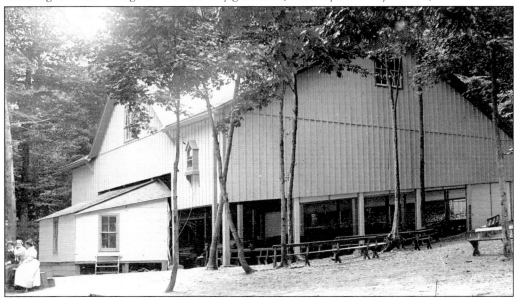

These three ladies are waiting in front of the auditorium on the assembly grounds for the next lecture of the day. During the week, there were at least two lectures and two musical concerts daily. Also notice the large clock on the outside of the auditorium at the entrance to the building. Many young Findley Lake children experienced their first motion picture in this auditorium. Movies were shown each night during the third week of programming the last few years of the Lakeside Assembly. Although the projectors would fail often and the films themselves were in poor condition, the way the pictures moved was quite a novelty back then. (Courtesy of John C. Peterson.)

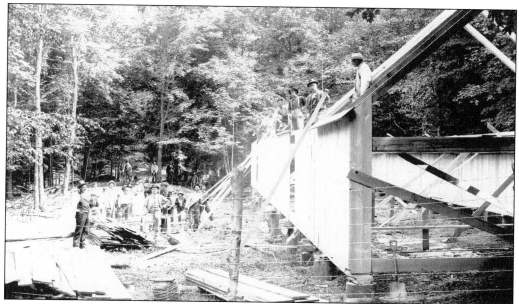

By its third season, the Lakeside Assembly was moving ahead rapidly with the construction of privately owned cottages and assembly buildings and the improvement of the grounds. Building lots were selling for $75 to $100 apiece. Common stock of the Lakeside Assembly Corporation was being offered for $10 a share. Louis Swartz, standing with his leg on the woodpile in this photograph, and his lumbermill crew would build many of the buildings and cottages on the grounds and around the lake during this time period. (Courtesy of John C. Peterson.)

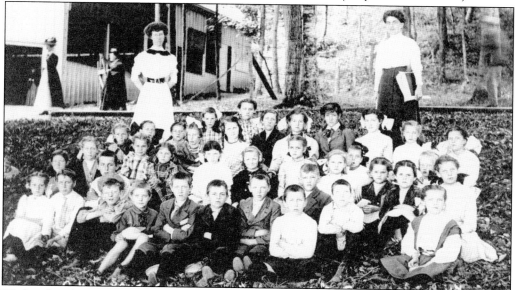

Wednesday, August 12, 1903, was children's day on the assembly grounds. The children's chorus performed the musical program *A Visit to Grandpa*. "Can you guess what's goin' to happen? No, you couldn't if you tried; we chillens have a picnic day—Goin' over to Lakeside! 'N the band is goin' to play, 'N we're all to have a boat ride. Won't that be jolly? Say!" (Courtesy of the Findley Lake and Mina Historical Society.)

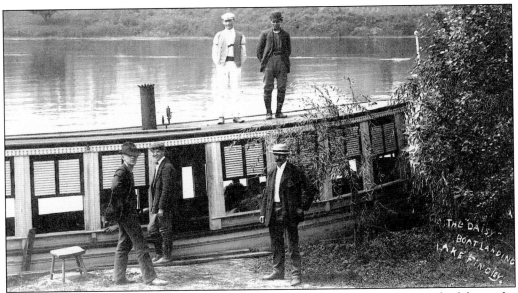

For 5¢, the *Daisy*, built by Chris Shum and his son Will, would run you across the lake to the assembly grounds dock. When leaving the dock to return and pick up additional passengers, the "toot, toot" of the four-horsepower whistle could be heard for miles. This was the luxury part of the two-horsepower steam engine. Will Shum is in the lower right-hand corner of this photograph. Many years later, in 1987, Rick Hines, a member of the Buffalo Aqua Club, would find what was probably the anchor to this boat buried deep within the mud of Findley Lake while he was scuba diving in this very same spot. (Courtesy of the Findley Lake and Mina Historical Society.)

The Grand Army of the Republic (GAR) was an organization devoted to the noble men who risked their lives in defense of our magnificent country in the times of great peril. GAR day at the Lakeside Assembly was always very special. The Lakeside GAR Association was formed and held its annual reunions on the assembly grounds to hear retold deeds of daring heroism performed by the defenders of our liberty. The GAR hall is now a private residence. (Courtesy of the Findley Lake and Mina Historical Society.)

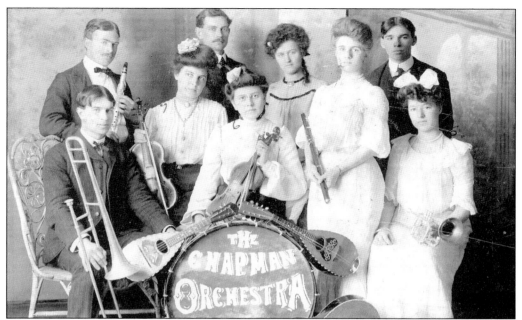

Having practiced all winter long, Professor Chapman had his orchestra fine-tuned and ready for the upcoming assembly season. As the resident orchestra, they distributed harmony throughout the assembly grounds and over the placid waters of the lake. Will TenHagen played the trombone, and Laura Van Sickle played the flute. (Courtesy of the Findley Lake and Mina Historical Society.)

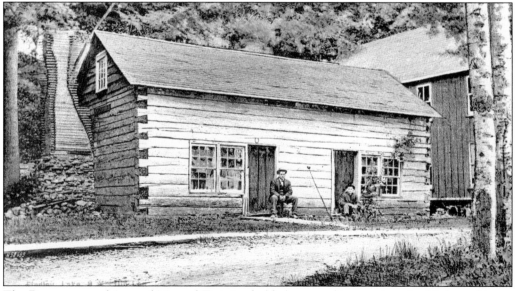

The Department of Art and Manual Training held classes and instructions in this log cabin on the assembly grounds. Children could sign up to participate in still-life classes, object drawing, design, pottery, clay molding, wood carving, topography, and landscape classes. Later postcards show that a skylight was added in the roof to allow natural light for the benefit of the artists at work. (Courtesy of Randy Boerst.)

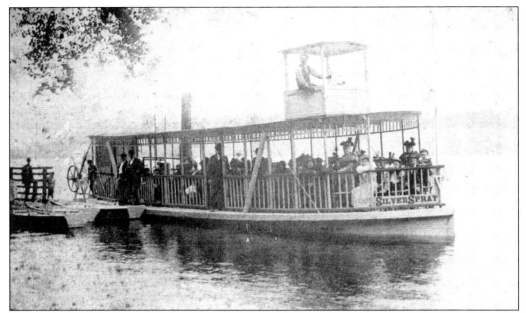

The original *Silver Spray* was built and operated by Louis Swartz, the person sitting in the captain's tower. This steamboat took passengers around the lake six times a day. One afternoon, when the water level was lower than normal, the steamboat got snagged on a stump and the passengers had to be taken to shore by rowboat while the boat was worked free. (Courtesy of John Swartz.)

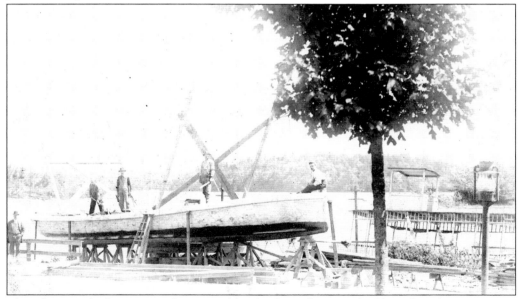

This photograph shows Louis Swartz and his lumbermill crew rebuilding the *Silver Spray* into a new double-decker steamboat. They wanted to carry twice as many passengers on one trip to maximize their profits. This also helped with the growing popularity of the assembly programs by providing transportation for more passengers at one time. Just as in today's world, the less time people have to wait in line, the happier they are. (Courtesy of Lola King.)

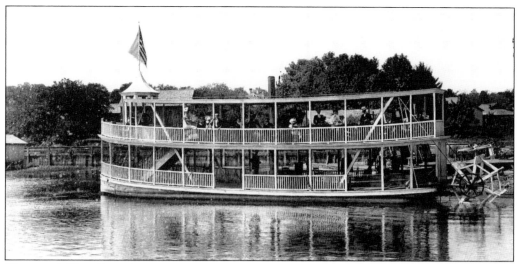

The grand *Silver Spray* is carrying twice as many passengers on one trip, as it is now complete with the second-level deck. Add in the American flag on top of the newly remodeled captain's tower and Louis Swartz's steamboat was the grande dame of Findley Lake. Later, the bottom deck of this boat was enclosed to provide the many passengers with added protection in inclement weather. (Courtesy of John Swartz.)

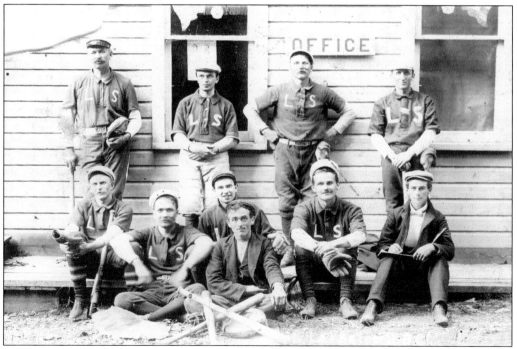

The Lakeside baseball team is pictured in front of the Swartz Lumber Mill. Louis Swartz was a member of this team and is seated in the bottom row, second from the right. Different clubs of the area competed against each other—similar to softball leagues today. America's pastime was played on top of the hill on the Lakeside Assembly grounds where Ball Diamond Road passes through today. (Courtesy of the Findley Lake and Mina Historical Society.)

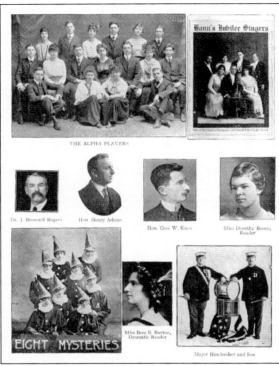

THE ALPHA PLAYERS

Bann's Jubilee Singers

Dr. J. Brownell Rogers

Hon. Henry Adrian

Hon. Geo. W. Knox

Miss Dorothy Bemis, Reader

EIGHT MYSTERIES

Miss Bess E. Barton, Dramatic Reader

Major Hendershot and Son

The directors of the Lakeside Assembly worked hard every year to secure various talents to inform and entertain the thousands of visitors each season. They did this by searching the whole Lyceum and Chautauqua circuits. Pictured is a sample of the prominent speakers of the day; the speeches included "Why God Made a Woman," "My Life among the Indians," and "Foot and Mouth Disease." Sundays were concert days, and the different concert bands and singers entertained and delighted the visitors on the grounds. (Courtesy of the Findley Lake and Mina Historical Society.)

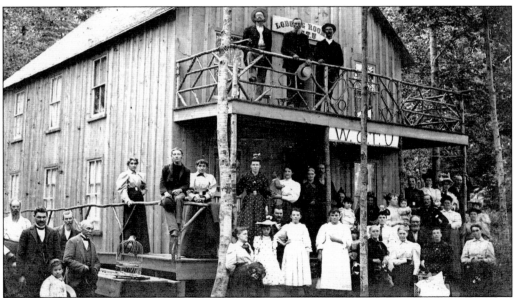

The Women's Christian Temperance Union (WCTU) had a very large following in the early years of Findley Lake. The WCTU sponsored an annual day during the assembly season on the assembly grounds. The programs of the time spoke of their "God-given mission to overthrow the saloon system." The building where meetings were held is pictured here. Rooms were available upstairs for overnight lodging. This hall has been remodeled since the days of the assembly era and is now privately owned. (Courtesy of John C. Peterson.)

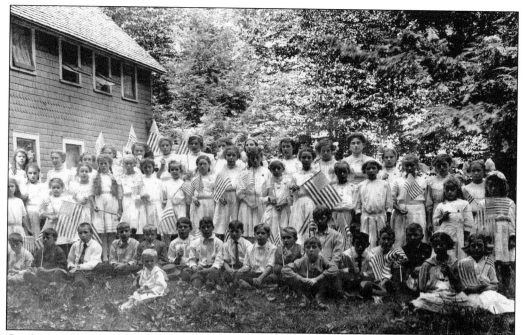

On the last day of the Lakeside Assembly season of 1910, the Children's School classes, directed by Florence Hay, pose for a patriotic, flag-waving photograph that still means so very much, even in today's world. (Courtesy of Jerry Tenbuckel.)

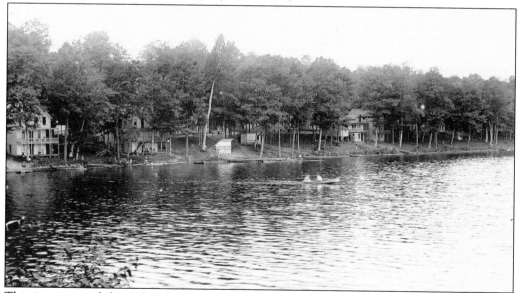

This is a view of the Lakeside Assembly grounds from one of the steamboats on the lake. Dr. William Tecumseh Sherman Culp's cottage is to the far left in this photograph. Dr. Culp was the superintendent of instruction and the platform manager at the Lakeside Assembly for 11 years until 1914. He was very popular and always promised a successful season each year as long as the dividends from the corporation were reinvested and not requested for individual gain. (Courtesy of Jerry Tenbuckel.)

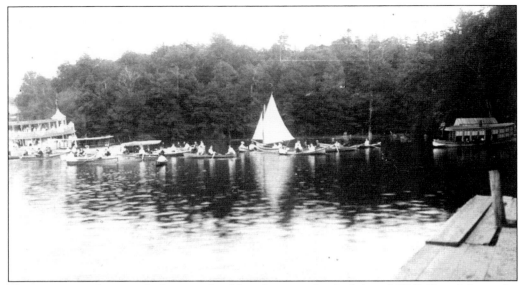

This is a great photograph showing the *Silver Spray* to the far left and Will Shum's boat, the *Daisy*, to the far right with all the rowboats and sailboats in the middle. What a busy afternoon on the grounds! This photograph was taken in the cove at the very end of the assembly grounds near where Howard's Point is today. Rowboats were also very plentiful to rent. If desired, a person could be hired to row for 25¢ for a half day. What a bargain! (Courtesy of John Swartz.)

Not only did the Neckers family have a general store that sold farming implements on Main Street in Findley Lake, but they also had a cottage where they rented out rooms to the visitors on the assembly grounds. The cottage was also for sale at this time, as the sign on the building indicates. Furnished rooms ranged from $1.50 to $2.50 per week. An unfurnished room could be rented for only $1 per week. With each room, the renter had use of a common kitchen stove and dining room. (Courtesy of Jerry Tenbuckel.)

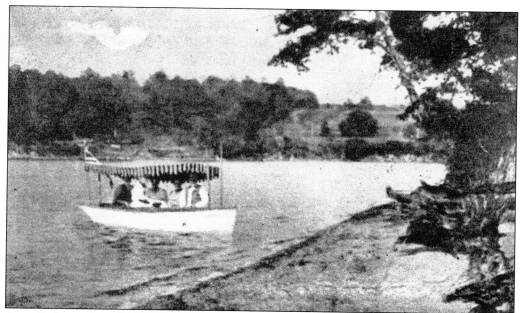

A small electric launch transported one passenger or a small group to the assembly grounds several times a day. This one is dropping off passengers in the Little Corry area of the lake. The New York State legislature granted an appropriation of $4,000 in 1904 to improve Findley Lake for boating, bathing, and fishing. The lake was dredged, and many stumps and logs were removed. This was accomplished through the efforts of W.L. Nuttall. (Courtesy of Randy Boerst.)

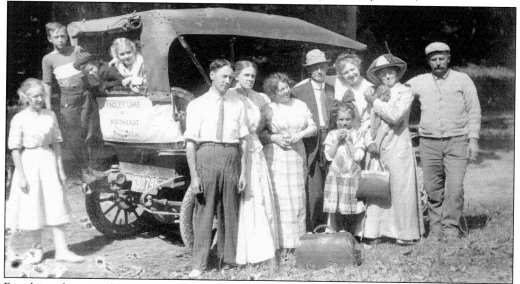

Reaching the assembly grounds and the Findley Lake area was accomplished in several ways. A stage line ran from North East, Pennsylvania, to Corry, Pennsylvania, and stopped in Findley Lake several times a day. There was a trolley line from Erie, Pennsylvania, to North East. There was an automobile passenger car that ran from North East to Corry and stopped in Findley Lake. There were also several "hacks" that transported people around the lake, and people even rode the daily mail stage. (Courtesy of John Swartz.)

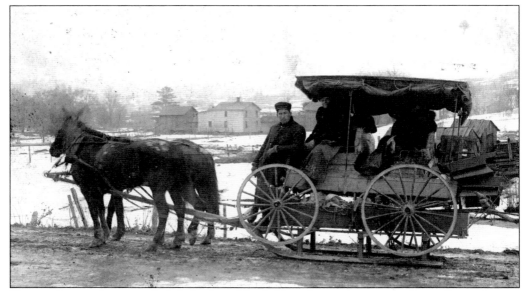

The mail stage line traveled daily from North East, Pennsylvania, to Corry, Pennsylvania, and stopped in Findley Lake. Notice how ingenious this arrangement was to handle all the weather conditions that could possibly be encountered. When snow was on the ground, sled runners were in use, but wheels were right there, ready to be used when needed. Should a storm suddenly pass through, the curtains tied along the top could be dropped and tied down to protect the travelers. Burdette Miles is the driver pictured. (Courtesy of the Findley Lake and Mina Historical Society.)

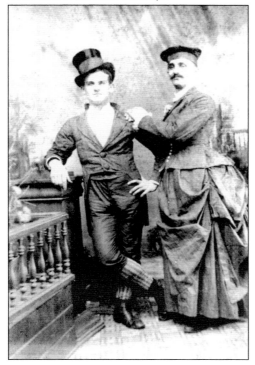

Emil Wollschlager is pictured with Louis Swartz, who is dressed as a Victorian woman. This photograph was probably taken at the assembly grounds. Could Louis Swartz—a member of the board of directors at the assembly grounds, the owner of the lumbermill, the owner and operator of the *Silver Spray,* and a member of a baseball team—also have been a Shakespearean actor? How could he possibly have had the time and energy? (Courtesy of John Swartz.)

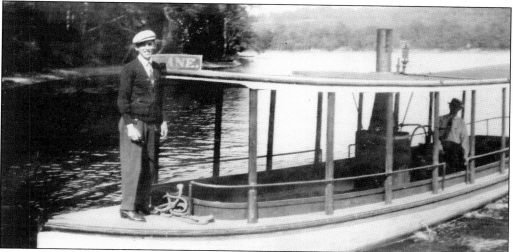

The *D.T. Lane* was one of the several steamboats that operated on Findley Lake. Captain Lane, who built steam engines for a living, operated this steamboat from his cottage on the Lagoon Island. Many people still remember this steamboat, as it operated for several years after the Lakeside Assembly folded. This steamboat lay sunken in the lagoon for many years until a salvage company from Jamestown recovered it. Once restored, the *D.T. Lane* was displayed in a museum in Buffalo, New York, for a period of time. (Courtesy of John and Sue Shifler.)

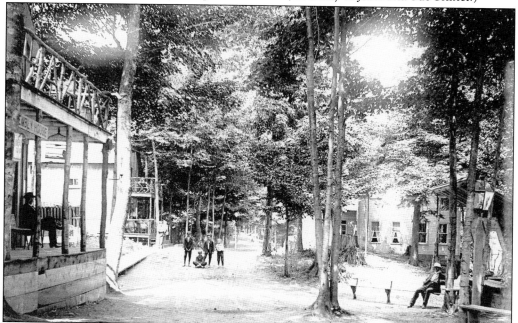

One final view of the "City in the Woods," as the assembly grounds were referred to in early advertising, was taken from Shadyside Road, looking north to the village. This photograph captures a particularly slow day on the grounds, as there are no crowds to fight in order to get to the next lecture or baseball game. Notice the wooden planks used as sidewalks on both sides of the dirt road, the Assembly House (Hotel), and the rest of the rustic-looking buildings. (Courtesy of John C. Peterson.)

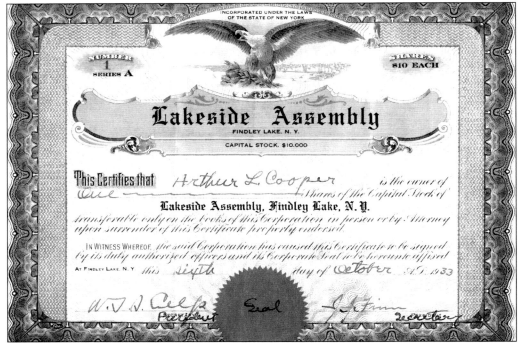

The Lakeside Assembly operated until 1915, when it was discontinued for financial reasons. There are many theories on why the assembly faltered: with a change in management, the corporate dividends were requested; a fire burned through the village and put many businesses out temporarily; the invention of the automobile enabled people to travel farther faster; the Chautauqua Institution on Chautauqua Lake was growing more successful. The corporation continued to sell stock until all its land and buildings had been sold. (Courtesy of Art and Mary Cooper.)

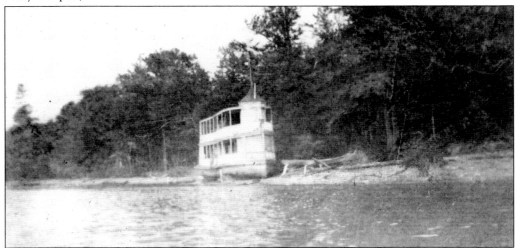

The end of an era! In August 1916, the grand *Silver Spray* was dry-docked and abandoned near the former Tony Litz's and the current Point of View cottage. It was eventually dismantled and used to build Harry and Mary Roberts's cottage on Sunnyside Road in the Little Corry area of Findley Lake. (Courtesy of Jerry Tenbuckel.)

Four

Scenes around This Beautiful Lake

The Lakeside Assembly attracted thousands and thousands of visitors to the Findley Lake area during its 20 years of programming. Many of those people stayed, built cottages, and opened additional businesses around the lake. The Lakeside Assembly created an economic boom to the area that equaled the growing economic conditions of the United States as a whole. The period after World War I to the mid-1930s saw a flurry of development around the lake, so much so that Findley Lake was described in the *North East Sun* as "one of the smartest, thriftiest and most prosperous little villages that we know of. It is very pleasantly nestled among the hills of old Chautauqua. Its citizens are all very enterprising and generous."

G.D. Heath, a retired businessman from Corry, Pennsylvania, purchased a large tract of land on the west side of the lake in 1915. This land consisted of 75 acres that he immediately named Shadyside. This land stretched from where Howard's Point is today to the lagoon area. At this time, Shadyside Road ended at the Y on the end of the assembly grounds. The old road circled back around what is now the Flag cottage. G.D. Heath built the roads that run around that part of the lake today. He developed the Deer Park on one of the parcels of land in the woods. Deer were very scarce in those days and were a real attraction for visitors to observe. He also put the first pair of European swans on the lake, which multiplied in time and became really enjoyable for people to watch for many years. The advent of motorboats on Findley Lake spelled the end of the beautiful swans on the lake.

At the same time the Lakeside Assembly was forming on the northwest side of Findley Lake, a group of people from Corry, Pennsylvania, that included X.A. Beebe, purchased a small tract of land on the southeast side of the lake. This area was at the time known as "Knowles Woods" or the "Spirit Land," named after Jeremiah Knowles, who settled on this part of the lake when there was not a public road in the vicinity. He was said to have been a civil engineer and is credited with having surveyed the first public road on this part of the lake. Because of the influx of people from Corry, Pennsylvania, building cottages in this area, it quickly became known as Little Corry.

Just down from Little Corry was Gallup's Lake House. Myron C. Gallup's family opened this in 1881 on the grounds that are now part of Camp Findley. This development consisted of a hotel, dining room, dance hall, and boating and fishing complex—a real resort destination of the time.

Gallup's Lake House was the summer resort of the time, with beautiful views of the upper end of the lake and the Big Island. The steamboats and stages ran daily to and from Gallup's Lake House to accommodate the guests. (Courtesy of Jerry Tenbuckel.)

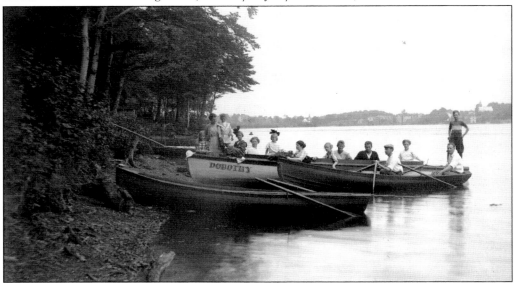

Members of the Swartz family are returning to their cottage after an afternoon boating on a calm day on their lake. This was always a regular family affair, and as the picture shows, it took three rowboats and one electric launch, the *Dorothy,* to accommodate most of the family. The *Dorothy* was named after one of Louis Swartz's two daughters. This area of Findley Lake was located on the shore of their cottage in the Lakeside Assembly area. The Swartz family cottage is still standing (almost sitting) on Shadyside Road, close to its original architectural condition. The cottage was no longer in the Swartz family after the 1940s. (Courtesy of John Swartz.)

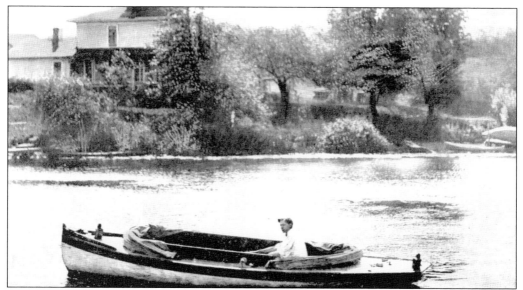

Louis Swartz was on the board of directors of the Findley Lake Development Corporation, which tried for years to develop the opposite end of the lake, known as Woodland Shores. The corporation was never really successful until the late 1940s and early 1950s, when his son Lawrence Swartz sold many of the remaining building lots. Although Bert Giles is pictured in Swartz's boat, Lawrence Swartz made regular trips up to that end of the lake, where he set muskrat traps and transported the trapped animals back and forth in this boat. On one trip, it was reported that he had more than 120 muskrats overloading the boat. This boat was also used to help float the newly cut logs down the lake to the mill. (Courtesy of Randy Boerst.)

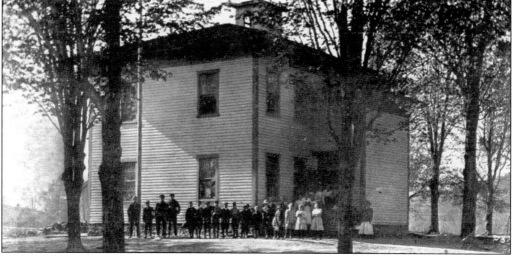

The Findley Lake Union School was built in 1869 on one acre of land owned by William Selkregg. It was located on the north side of what is now School Street. The new building was finished before the street (College Street then) was completed. The schoolchildren walking from the east side of the village had to cross the creek on a wooden plank, sometimes with disastrous results. This building was built with 20 cords of wood and is still standing today as the Small Emporium Antique Shop. (Courtesy of Randy Boerst.)

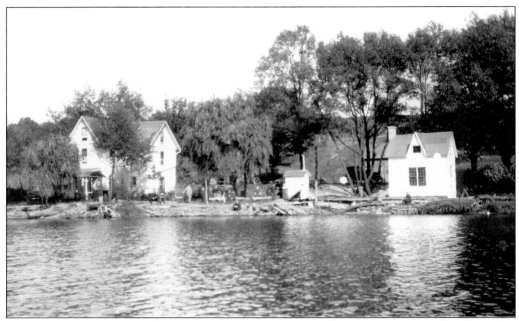

The Edgar Amidon family built this housing complex on the northeast side of Findley Lake. The main house is to the left in the photograph. Amidon desired a place to escape from his children for some peace and quiet. He built the smaller house to the right to achieve this. The outhouse is the smaller building in the middle. Today, these are two separate private cottages on Sunnyside Road. (Courtesy of Randy Boerst.)

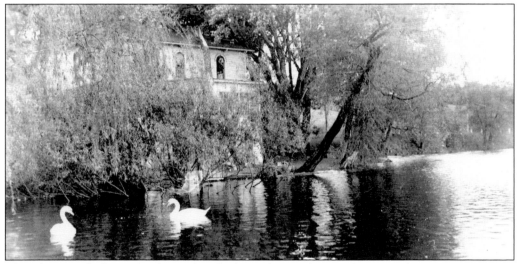

This photograph shows the front of Will Shum's home along with a pair of European swans on the lake. This house was quite a showplace in the 1890s. Shum was born in this house and lived his whole life there. He operated the *Daisy*, which he and his family owned, and worked at Louis Swartz's mill as a laborer. In addition, he operated the hand-cranked cylinder press at the Findley Lake Breeze office owned and managed by Joseph and Julia Boorman for 27 years. This house is no longer there, having been torn down and replaced with a larger, more modern cottage. (Courtesy of the Findley Lake and Mina Historical Society.)

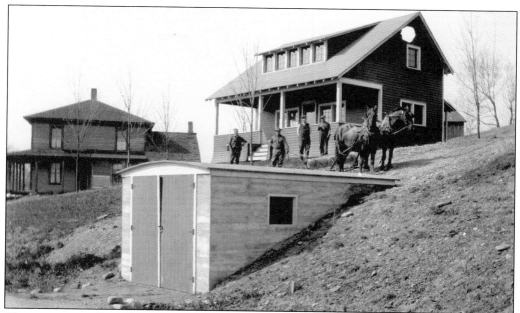

These men are tilling the ground to plant new grass after building this new garage next to the road. This house and garage were built by Bob Wakely. The garage was torn down in the 1930s, and the house was demolished just recently. In the background is the former United Brethren parsonage house. (Courtesy of Randy Boerst.)

The first family to build on the little peninsula jutting out on Sunnyside Road was Al and Mary Smolk. They operated several businesses on Main Street. Lawrence Swartz, as an experiment, planted the large willow trees pictured here. He always had trouble with freshly cut logs that became stuck in this shallow area as he floated them down the lake to the mill. He thought that someday the land would be viable to build on, and by planting the trees the land would fill in and become usable. For the most part, this came true, although some landfill had to be used to speed up the process. (Courtesy of the Meese family.)

Just south of Smolk's Point is the area that used to be called Giles Point. Bert Giles and his family owned this land and farmed 47 acres across the street. Their farmhouse stood in the empty lot between where Johnson's and Sunnyside Restaurant are today. During the 1950s and 1960s, this area was a popular camping site, as well as a makeshift trailer park. (Courtesy of the Meese family.)

In August 1924, the Findley Lake Silver Fox Company was formed. The principal owners were Ralph Wells, Carl Krantz, Mark Warner, George Bennett, Louis Swartz, Lee Root, and John Mottier. The company was formed for various reasons, including buying, selling, breeding, and raising furbearing animals. Les Hulburt, pictured here, lived on the farm as the caretaker. The venture was successful until the 1930s, when it went bankrupt. Today, Johnny Gibbons raises prize Appaloosa horses on the farm. He always found it ironic that his father-in-law, Hulburt, slaughtered horses on the farm to feed the foxes, and he now raises horses on the same farm. (Courtesy of Art and Mary Cooper.)

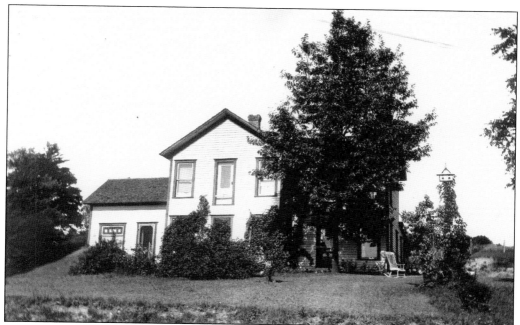

This is a photograph of the Couthard farmhouse, which later belonged to the Seltzers. It was a very popular place to get milk, butter, and eggs for the summer residents of Little Corry. After Gallup's Lake House, most of the land toward the south end of Findley Lake was made up of dairy farms and very few private cottages. This home is a private residence today and no longer a farmhouse. (Courtesy of Randy Boerst.)

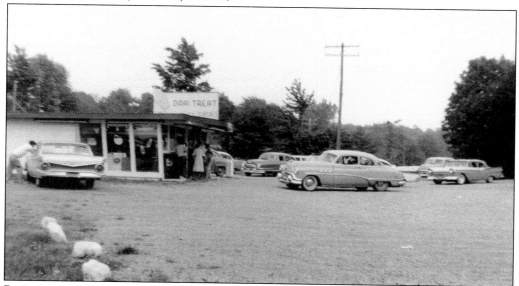

Beginning in the early 1960s, the Dairy Treat was a popular spot for local teenagers each summer. It was built by Howard and Helen Willis. Helen was Autumn "Boots" Burmaster's sister. Peek'n Peak also owned it at one time. Jack and Judy Chamberlain now own and operate it as Sunnyside Restaurant. They continue to sell ice cream, but of the homemade variety, in more than 40 flavors each summer. (Courtesy of June Wright.)

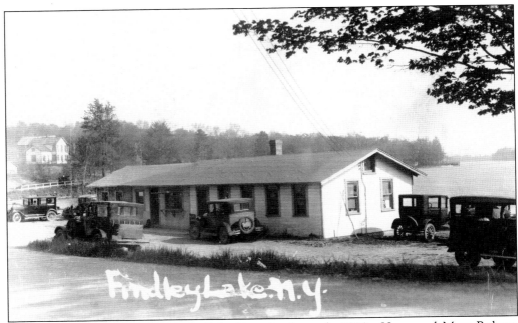

Roberts Stand started out as a small building in the early 1920s. Harry and Mary Roberts operated a basic food concession stand on this spot for people traveling around the lake in their automobiles. They later expanded the building so they could live there as well. This photograph shows the newly remodeled stand in the late 1920s. Across the street was a dance hall, which later became a skating rink. Also, notice the clear view of the Seltzer farmhouse in the background. (Courtesy of Jerry Tenbuckel.)

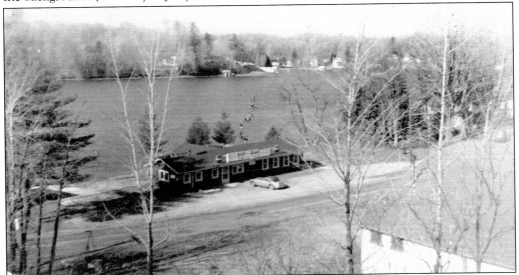

Al and Mary Smolk operated this food stand as Smokey's after they bought it from the Robertses. Later, the Cote brothers purchased the business and operated it as Ship'n Shore through the 1950s and early 1960s. Other owners have been the Dumars, Hutchinsons, Stan and Arti Martin, and Peek'n Peak. This once popular building was torn down to make way for two privately owned lakefront cottages. (Courtesy of Art and Mary Cooper.)

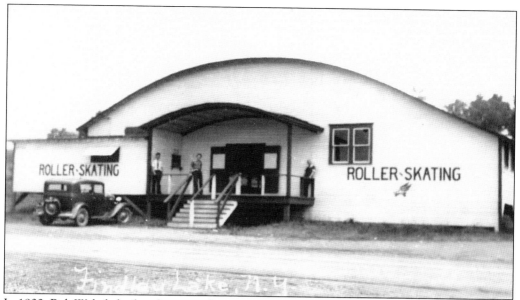

In 1932, Bob Wakely built a skating rink on a site that several different dance halls had previously occupied. The very next year, Harry Teets, from Schenectady, New York, leased the business for a percentage of the profits. At first, the skating rink operated as a dance hall on Saturday nights with live music. It was a semiformal affair requiring the gentlemen to wear white shirts and black pants, while the women wore long, fancy dresses. There was no square-dancing, just "really nice dancing," as Minford Peterson was quoted as saying. (Courtesy of Jerry Tenbuckel.)

Clarence "Swanee" Swanson was a permanent fixture at the skating rink every night, along with Mary Roberts on the organ. Swanee repaired and maintained the roller skates and also operated the roller-skate-rental business. (Courtesy of the Findley Lake and Mina Historical Society.)

Certificate

FINDLEY LAKE ROLLER RINK
Findley Lake, N. Y.

This is to certify that

Jackie Cooper

HAS COMPLETED ALL REQUIREMENTS
IN THE

Intermediate Class of Roller Skating

Nancy Hurlburt
Carol Cooper
Asst. Instructors

Boots Burmaster
Mgr. & Instructress

October 27, 1961
Date

Clayton and Autumn "Boots" Burmaster purchased the skating rink from Bob Wakely and operated it through the 1970s. Skating lessons for beginning, intermediate, and advanced levels were offered. It was a popular pastime for the children of the Findley Lake area to learn how to skate like their parents did. (Courtesy of Art and Mary Cooper.)

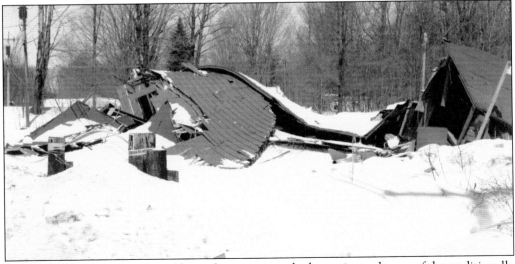

The roof of the skating rink could not always support the heavy ice and snow of the traditionally long winters around Findley Lake. It actually collapsed and had to be rebuilt a total of seven times. The harsh winter of 1993 saw the final collapse of the skating rink, as seen in this photograph. This closed a chapter on a long and glorious era in Findley Lake history. Today, the debris has been removed and the lot remains empty. (Courtesy of Jay and Vicki Altman.)

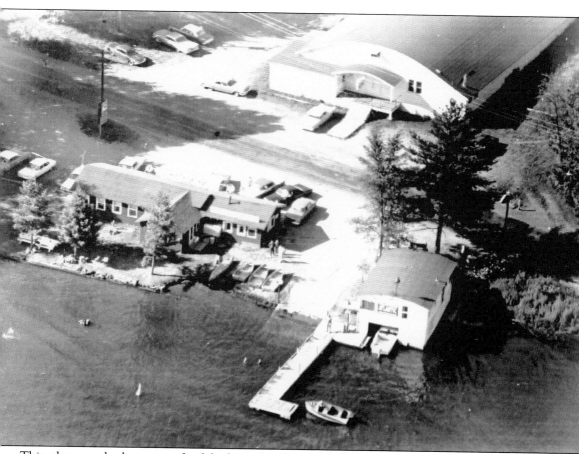

This photograph shows one final look at the skating rink and Ship'n Shore in its heyday. Many young people from the area swam in the lake here for the first time, laid out in the sun to get that perfect tan, rented canoes, launched their brand-new motorboats, roller-skated every night, ate burgers and fries, had their first malt, bought candy, and played pinball. It was the place to be and be seen in Findley Lake during the 1950s and 1960s. Many friendships and romances began at these two places. Whole generations of Findley Lakers have nothing but great memories and fond stories to pass on to future generations who will not be able to experience the joy of it all. (Courtesy of Randy Boerst.)

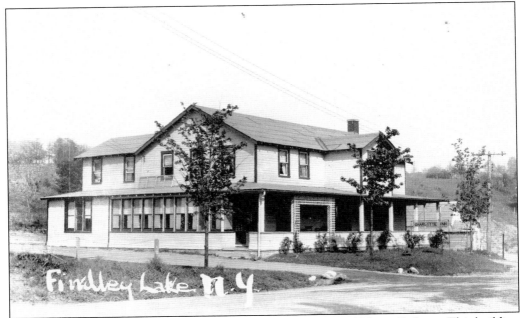

Bob Wakely built the Charlotte Inn in the 1920s for George and Hattie Roberts. This building was located on the empty lot that now exists between the old skating rink and Sunnyside Restaurant. It operated mainly as a restaurant, but it had several rooms upstairs for overnight guests. The showcase of the inn was the very large dining room that ran across the front of the building with many windows so patrons could sit and view the beautiful lake while dining. This building eventually burned down and was never rebuilt. (Courtesy of Jerry Tenbuckel.)

Dr. X.A. Beebe of Corry, Pennsylvania, purchased a small tract of land in 1894 from a descendant of Alexander Findley; the land became Little Corry. He proceeded to build the very first summer cottage on this part of the lake. Alexander Knowles, who was a descendant of Alexander Findley, originally surveyed Little Corry Road, pictured here. The name of the road was changed to Sunnyside Road in 1968. (Courtesy of Jerry Tenbuckel.)

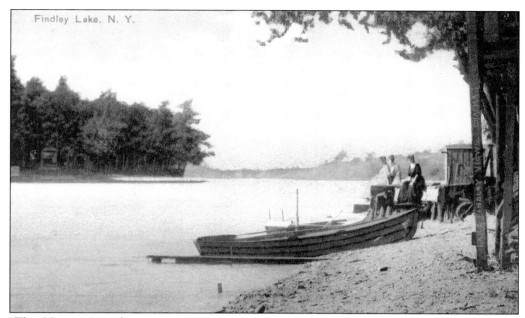

Findley Lake. N. Y.

"The Narrows" is the narrowest section of the lake. This area contained a stream that connected two ponds until Alexander Findley built his dam. Written on the back of this postcard is the following description: "This area was dugout by ox teams using slip scrapers by William Ross Saunders around 1869. This made it easier to float the fresh cut logs down to the mill." (Courtesy of Jerry Tenbuckel.)

This is the actual contract agreement, dated June 15, 1918, between Dr. W.H. Wesley from Pittsburgh, Pennsylvania, and Louis Swartz to construct one cottage for $750 in the Little Corry area. Today, this cottage is named the Point of View. Swartz constructed many of the earlier cottages around the Findley Lake area. Many of these contracts for other cottages that were built by Swartz still exist today in the private collection of Swartz's grandson, John Swartz. (Courtesy of John Swartz.)

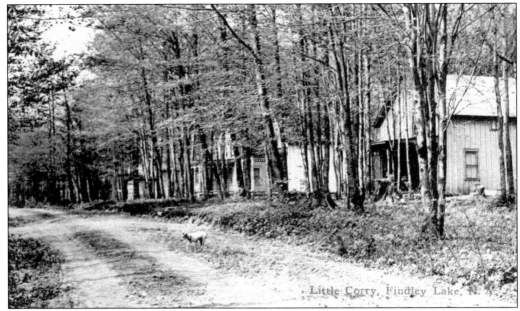

By 1910, there were more than 20 cottages constructed in this area of the lake. The majority of the owners were from Corry, Pennsylvania, and very quickly, this section of Findley Lake became known as Little Corry. The *North East Sun* of August 8, 1914, reported, "Findley Lake summer resort is booming. More people have visited Lake Findley [*sic*] this season than ever before. Little Corry, especially, is booming. In one day twelve lots were sold and the following day six more lots were bargained for." (Courtesy of Jerry Tenbuckel.)

W.T. Kopke, a men's clothier from North East, Pennsylvania, opened up a satellite store in the Little Corry area of Findley Lake. Mr. Wing, probably pictured in this photograph, operated a grocery store there until it closed in the 1930s. Wing was blind, and the customers always had to make their own change, as he could not see to do it. This building has experienced numerous renovations and has been the home of Beulah Smith and her family since 1948. She operated the Lake Beauty Shoppe for select customers out of this home until just recently. (Courtesy of Randy Boerst.)

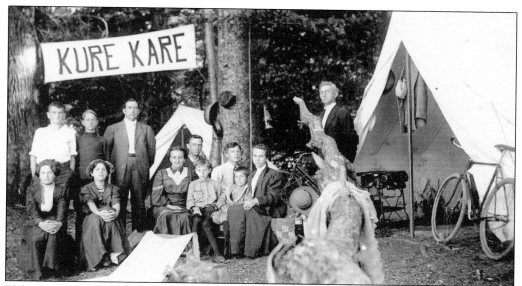

Elaborate camping stories from Findley Lake, such as the following, were written up extensively from 1914 through 1918 in the *North East Sun*. "On Saturday last when the writer and party arrived we at first thought that Barnum and Bailey's circus was exhibiting in Little Corry. Four large tents were flying and the locality in the beautiful grove appeared to be alive with people. Upon investigation we learned that it was the tented aggregation of city engineer C.C. Hill and florist George Selkregg. They have a beautiful camp, the stumps all being decorated with ferns and the tents rigged out in a gala fashion. The campers all appear to be enthusiastic over the location and are apparently enjoying themselves, boating, bathing, strolling in the grove, fishing, shooting and some of them flirting!" (Courtesy of Jerry Tenbuckel.)

A calling card of Myron C. Gallup and J.N. Stephens is pictured here. One of the attractions of Gallup's Lake House was hunting the best game around. These two gentlemen made sure that the woods were completely stocked with plenty of Black Breasted Reds for their guests to test their marksmanship on. (Courtesy of Jerry Tenbuckel.)

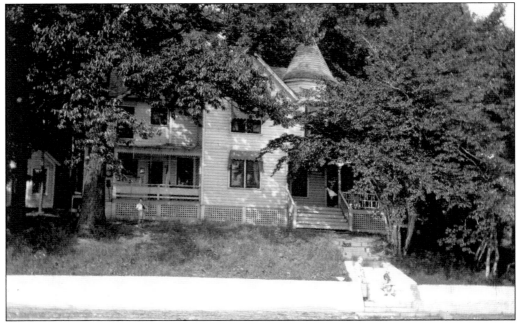

A real showplace during the 1920s, this cottage has a great view of the upper end of the lake and the Big Island. The original owners were the Barlow family of Corry, Pennsylvania, who resided there when this photograph was taken. The beautiful turret is no longer part of the house and was taken down years ago, but the house, break wall, and steps to the lake are still in great shape and used regularly by the current owners. (Courtesy of Randy Boerst.)

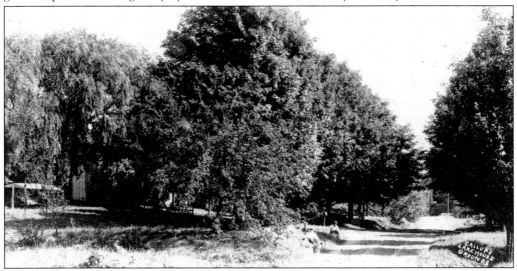

This is an early photograph of the grounds of Gallup's Lake House, which Myron C. Gallup inherited from his father, Orlando Gallup, in 1881. The property originally consisted of 102 acres of land. Myron and his wife, Mate, developed a resort complex that would have rivaled Peek'n Peak today. It consisted of a hotel, a dining room, a dance hall, a stream for trout fishing, woods for hunting fowl, boating, and boat racing. The boathouse was even big enough for two sets to dance. (Courtesy of the Findley Lake and Mina Historical Society.)

The grounds of Gallup's Lake House consisted of croquet courses, a farm, a stream, and large sections of heavily overgrown thickets. Several cows were raised on the farm; the streams were always stocked with trout for the guests to try their luck fishing; and the abundance of overgrowth provided the perfect hunting grounds for the prized woodcock. The hammocks overlooked the lake and provided weary travelers with much-needed rest and relaxation while watching the steamboats traveling up and down the lake. (Courtesy of the Findley Lake and Mina Historical Society.)

LaVanch and Lena Gallup are pictured with a friend between them, having some fun with Paul Swigart, a hired hand. This photograph was taken on the grounds of Gallup's Lake House in July 1905. The homemade swing was a popular spot for guests to spend the afternoons, forgetting about life for a while. (Courtesy of the Findley Lake and Mina Historical Society.)

Gallup's Lake House was a two-story square building with long verandas and, although not overly large, was well furnished inside. The parlor was decorated with handsome Brussels carpets, upholstered furniture, a huge array of photographs, and an upright piano, which cost $325 in 1905. Mate and her two daughters, Lena and LaVanch, were all fine musicians. They performed at many dances and parties that were held on the weekends at Gallup's Lake House. This building was torn down in 1946 after the United Brethren Church acquired the property. (Courtesy of Randy Boerst.)

FOURTH OF JULY.

Yourself and Ladies are cordially invited to attend an

Independence Party

at the Lake House, Findley Lake, N. Y.,

Thursday Evening, July 4th.

Fine Music will be in Attendance.

Bill, $1.00.

Mrs. M. C. Gallup, Propr.

The Fourth of July was just as big during the early 1900s as it is today around the lake. These parties attracted many local couples as well as the out-of-town guests. Lena Gallup officiated on the piano, Will TenHagen played the trumpet, and Clarence Lathrop played the fiddle as guests filed into Gallup's Lake House in sets of two. The annual Independence Party began at 9:00 p.m., with a cover charge of $1. (Courtesy of Jay and Vicki Altman.)

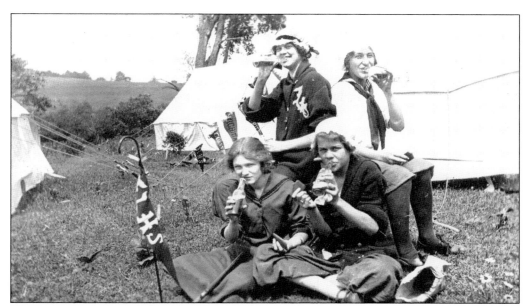

These young women probably celebrated their graduation from Findley Lake High School on the grounds of Gallup's Lake House. Along with the traditional high-school pennant, additional pennants from the University of Michigan, Corry, Pennsylvania, and the University of Pittsburgh are hanging on the tent ropes. Graduation parties have not really changed all that much over the years, have they? (Courtesy of Art and Mary Cooper.)

Paul Swigart was born in Cleveland, Ohio, and worked for the Gallups as a hired hand. One of his responsibilities was operating the Mint, which was a stand located in front of Gallup's Lake House that sold hot dogs, ice cream, and real-estate lots! This stand quite possibly represented the first real-estate office in Findley Lake. Norman Neckers operated this stand through the 1930s after Paul Swigart passed away in October 1925 at the Corry Hospital in Corry, Pennsylvania, at the age of 51. (Courtesy of Randy Boerst.)

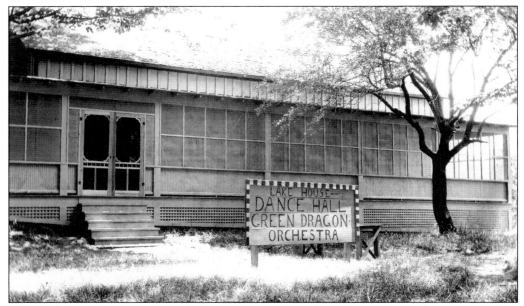

The Gallup's Lake House dance hall was popular throughout the Findley Lake area as a place to listen to great music, watch local bands perform, and dance the nights away. Various local musical ensembles performed once a week, such as the Green Dragon Orchestra, Art Chapman Orchestra, and the McInnes Quartette from Corry, Pennsylvania. Mate and Lena Gallup sometimes played the piano and sung one of their compositions to the delight of the guests on those evenings. (Courtesy of Randy Boerst.)

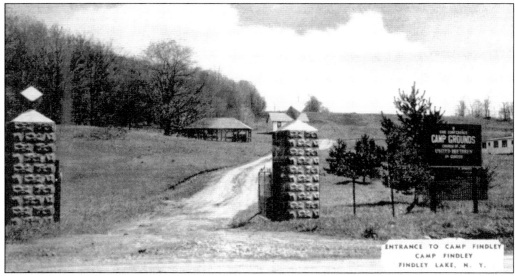

The Bible Conference and Leadership Training School of the United Brethren Church held an annual 10-day conference in Findley Lake from 1927 through 1935. The church on Main Street was the center of activities in addition to various classrooms that were used in nearby businesses. Often, a large tent was also set up to accommodate the large crowds. The Clymer State Bank foreclosed on the Gallup's Lake House property and Mate Gallup in 1934. (Courtesy of Randy Boerst.)

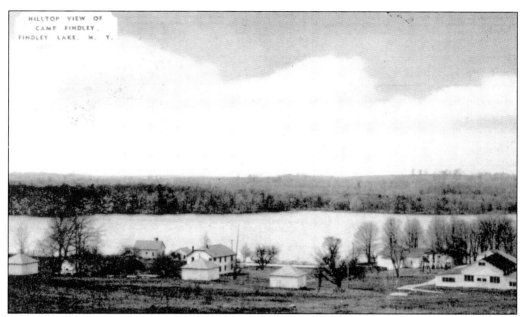

The Clymer State Bank sold the Gallup property to the Erie Conference of the United Brethren Church in April 1936 for $2,000, which was the balance of the back taxes owed. Work immediately began to put the property, which had been neglected in recent years, back into proper condition to entertain the Bible Conference and Leadership Training School in July of that first year. (Courtesy of Randy Boerst.)

The Gallups' old barn became the tabernacle, which is pictured here. It is still in use today. Gallup's Lake House was converted into a dormitory and, in 1946, was torn down. The dance hall became the dining hall and was torn down in 1952. The first Bible conference at the new Camp Findley grounds was held from July 13 to 24, 1936. More than 1,000 people attended the conference programs for one or more days that first summer at the new lakefront property. (Courtesy of Randy Boerst.)

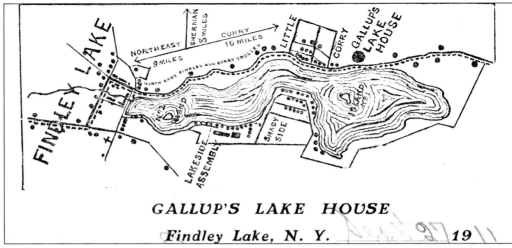

GALLUP'S LAKE HOUSE
Findley Lake, N. Y.

This map of Findley Lake from 1911 shows the location of the early buildings around the lake and the proposed trolley line connecting North East, Pennsylvania, Findley Lake, and Corry, Pennsylvania. This is from stationery belonging to Myron C. Gallup and proposes raising $20,000 to $25,000 to build the trolley line. Gallup also indicates that it might be too late, as two other businessmen were in Findley Lake on that day, investigating putting in a trolley line. The proposed trolley line was advertised for several years in the Lakeside Assembly programs but was obviously never built for reasons that are not clearly known. (Courtesy of Ken and Barbara Neckers.)

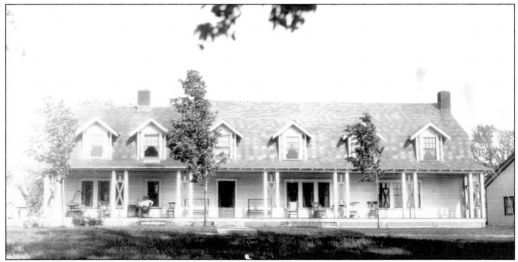

The Meadows Inn was a speakeasy, but before that, it was a legitimate business that legally served food and liquor, held dances, and rented out rooms. For a short time in the 1920s, alcohol could be served legally in the Town of Mina. During that time, live bands played on Saturday nights for the dinner crowd. Art Cooper Sr. and his family bought the inn in 1936 and renamed it the Algonquin Lodge. Many high-school proms and wedding receptions were held in the large ballroom over the years. Although it is a private residence now, little sinks with hot and cold running water are still in use in each of the 11 bedrooms on the second floor. Having hot and cold running water in your room was quite a convenience in the 1920s and 1930s. (Courtesy of Jerry Tenbuckel.)

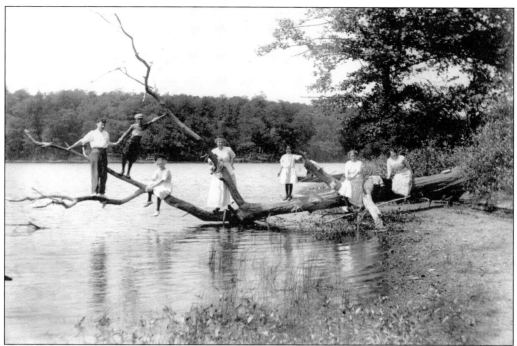

The Gaffney family enjoys a beautiful summer day playing on a fallen tree stump on the edge of Findley Lake. There were not many beaches on Findley Lake in the early 20th century, as can be seen in these two photographs, as the level of the lake was controlled by how much water was needed to operate the sawmill. A view down to Bell's Point shows the rough and underdeveloped shoreline of the lake. Pictured in the lower photograph is the steamboat landing in the Little Corry area. (Courtesy of John Swartz and Jerry TenBuckel.)

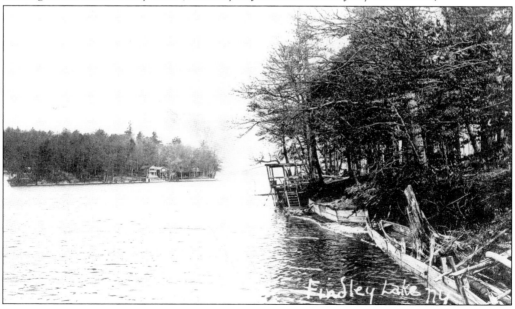

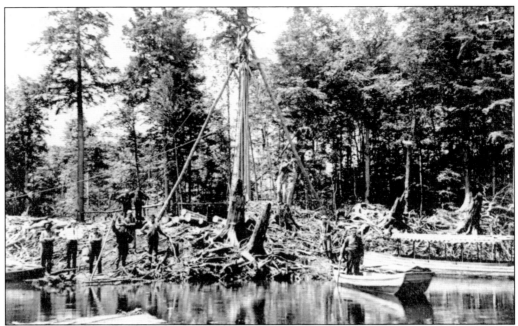

The entire section of the lake from where Meadows Road is today, south and west to the lagoon area, was known as "the stumps." This part of the lake was truly a naturalist's delight, as wild muskrats, beaver, fish, waterfowl, and birds made their home there. This group of men went to great lengths in 1904 to remove the many stumps and logs that cluttered the lower end of Findley Lake. Notice the contraption and the amount of stumps and logs around it. (Courtesy of the Findley Lake and Mina Historical Society.)

Three hundred acres of land, including two small ponds, were flooded to form Findley Lake. The many trees that made up the forests of this flooded land were cut off at water level in the early pioneer days. For years, hundreds and hundreds of tree stumps lurked beneath the cool, dark waters. The lake is traditionally lowered in October to its winter level, and as recently as 1985, this was a common scene at the south end of the lake. (Courtesy of Bob and Christie Ferrier.)

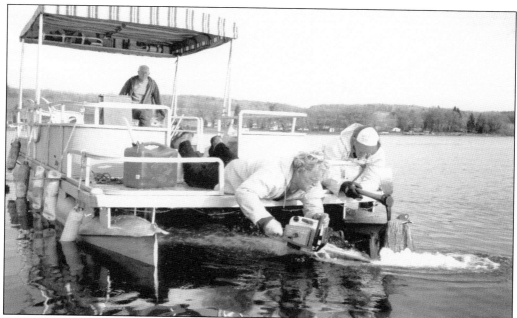

A group of men led by Bruce Kern and Bob Ferrier, along with other members of the Findley Lake Property Owners Association, removed more than 500 stumps from the lake in the winter of 1985. Although there are still a few stumps in certain parts, this group made the majority of the lake much easier to navigate for motorboats. (Courtesy of Bob and Christie Ferrier.)

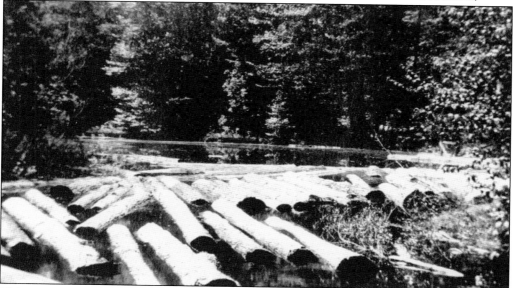

This was a common scene on Findley Lake from the early days of Alexander Findley right up until the last days of the mill in the 1940s. The lake was formed specifically to transport freshly cut timber to the mill and also as a source of power to operate the mill. Boating and recreation on the lake were always secondary and, as you could imagine, at times very difficult because of the floating logs and the inconsistent water levels caused by the operation of the sawmill. (Courtesy of John Swartz.)

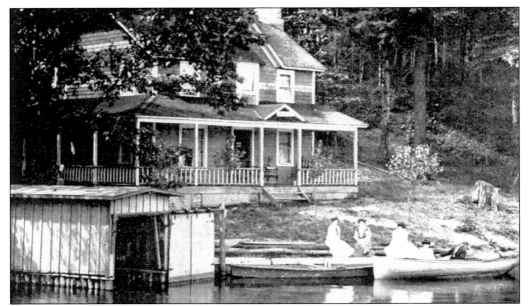

In the early 1900s, G.D. Heath built the cottage pictured here and named it the Grand View, located right next to the lagoon. Heath was a businessman who bought and sold vehicles on Main Street in Corry, Pennsylvania. He also operated a "hack" delivery service around the lake during the Lakeside Assembly years. After retiring, he devoted all his time to developing the area from the lagoon to the assembly grounds. He divided this area into lots, sold them, built the roads, started a public water system, and named it Shadyside. (Courtesy of Jerry Tenbuckel.)

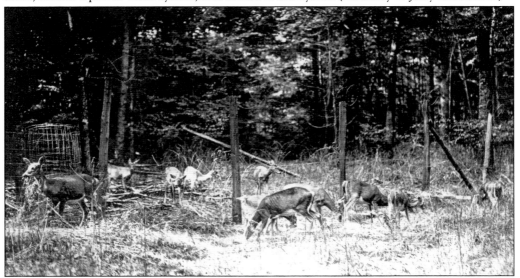

G.D. Heath was probably most famous for the several acres of woodland he fenced in to create the Deer Park. Deer were very scarce during the early 1920s in this part of the state. Heath brought deer to the area, and it became a real attraction for visitors coming to Findley Lake after the assembly closed down. James Vesey was the local caretaker who looked after and fed the animals at the park. Wild pheasants were also brought in to observe along with the deer. (Courtesy of the Findley Lake and Mina Historical Society.)

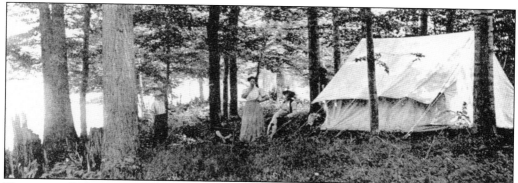

The area called Howard's Point today was commonly known as Zynglesyde Point in the late 1800s. This land was very heavily wooded, and campers had to hike to this spot overlooking the lake because the road was not developed until about 20 years after this photograph was taken. This was a popular site for campers who were very organized and enjoyed the secluded area, which offered great views of the lake. (Courtesy of Randy Boerst.)

This is formal stationery from the Zynglesyde campers, dated 1887. Mrs. Manley Crosby was the chaperon the second year. Nineteen members are listed. This occurred eight years before the Lakeside Assembly became active in Findley Lake. (Courtesy of Randy Boerst.)

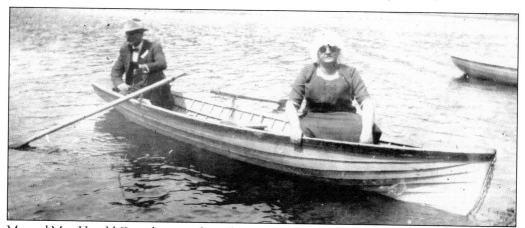

Mr. and Mrs. Harold Carnahan row from their cottage on the assembly grounds to the boat dock of Gallup's Lake House. They owned most of the land on Shadyside Road between Howard's Point and Alice Ives's pink ranch home. This area was called Carnahan Heights. Mr. Carnahan sectioned it all into lots and sold them during and after the Lakeside Assembly years. He was also the founder of Carnahan's Department Store, located first in North East, Pennsylvania, and now in Jamestown, New York. (Courtesy of Art and Mary Cooper.)

This postcard shows the Beechcliff cottage as it looked in 1906, complete with crossed oars on the porch. The steamboat dock was also in front of this cottage owned by A.O. King. This dock served the growing number of cottage owners in G.D. Heath's development. It was also a place where passengers could get off the steamboat and walk up into the woods to view the Deer Park. (Courtesy of Jerry Tenbuckel.)

This view looks from G.D. Heath's development to the village approaching the Lakeside Assembly grounds on Shadyside Road. The cottage to the right is the Lookout, shown as it appeared in the 1930s. This cottage was originally the Octagon Bandstand Gazebo on the assembly grounds. The old Lakeside Assembly auditorium was located across the road from this cottage. It collapsed in a loud rumble heard for miles during the fall of 1922. Part of its foundation is still visible today. (Courtesy of Jerry Tenbuckel.)

This ornately charming home is located on North Road, just off Main Street. It is often called the Capitol Building by longtime Findley Lake residents because of its stately architectural features. William Spears originally built this home for his bride, Flora Haskill, a granddaughter of Alexander Findley. They are pictured standing next to their horse and buggy. This beautiful home is an antiques and garden-stone workshop today, minus the lovely tower. (Courtesy of Doris Durst.)

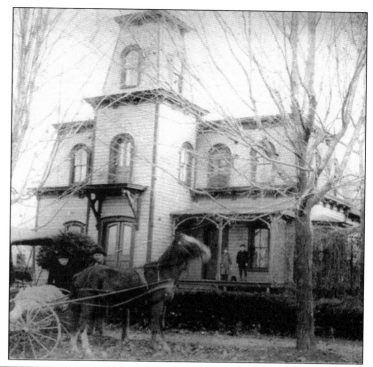

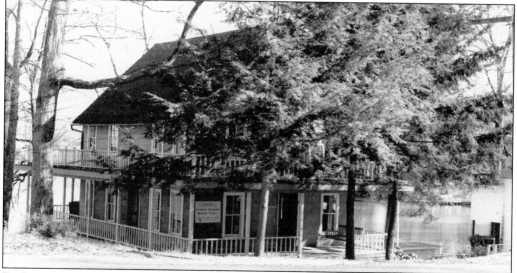

Dr. R.L. Foulke, a minister and the director of the Lakeside Assembly in 1915 (the final season), owned this cottage. His daughter Millie married Hal L. Meese Sr., and they inherited this property. Millie was one of the originators of the Findley Lake Property Owners Association. Cornell University used this cottage as the headquarters and research station in the 1960s, when they, along with Hal Meese Jr., conducted the first extensive watershed study of Findley Lake. This study was used to combat and control the growing weeds in the lake and the effect of the chemicals on the lake, the biological life in the lake, and the watershed areas. (Courtesy of the Meese family.)

Waynard L. Keith rented this store from Lon Hotchkiss and opened a restaurant called Winks in 1937. In 1938, Keith married, and he and his wife, Millie, bought this building. They immediately remodeled the upstairs and called this their home. In 1941, Keith combined the two stores in the building and started a sporting goods store that sold fishing tackle, boats, motors, skis, and bait. He also added two gas pumps in the front and one in the back for the boats on the lake. In the 1950s, Keith built a house on the lake behind the store. After Keith passed away in 1973, Millie changed the name of the restaurant to Millie's, closed down the sporting goods store, and ran the restaurant herself until 1994, when her daughter and son-in-law took over. The restaurant closed for good in 1997. Gifts by Dander and Gloria's Home Accents now occupy both sides of the building. (Courtesy of Jay and Vicki Altman.)

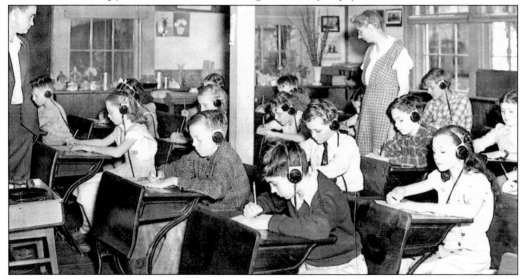

Coach Colburn and Naomi Snell, a teacher, monitor an audio lesson inside the Findley Lake Union School classroom during the 1946–1947 school year. The students are, from left to right, as follows: (first row) Jerry Baughman, Lois Jenkins, Bill Scarem, and Leroy Paddock; (second row) unidentified, Gloria Ott, Bill Hair, and Jeanette Paddock; (third row) unidentified, Deforest Bliss, and June Ward (behind the teacher); (fourth row) Vincent Gorski and Carol Shields. (Courtesy of Carol Shields Burke.)

Five

WHAT TO DO?
WHAT TO DO?

As the popularity of the Lakeside Assembly grew each year, more and more families made Findley Lake their vacation destination. Many visitors from Buffalo, Cleveland, and Pittsburgh, as well as other towns, bought lakeside lots and built summer cottages. By 1910, Shadyside, started by G.D. Heath on the southwest section of the lake, was a much improved, healthy, happy summer place with more than 30 new cottages along the lakeshore banks. Little Corry, on the southeast side of the lake, was also flourishing with more than 20 summer cottages. Findley Lake quickly became one of the most popular summer resorts in western New York.

As the hamlet of Findley Lake flourished, people started to accumulate more money, and with that came increased leisure time and more cultured interests. The latest literature of the day was discussed at a club called Bell's Letters, which was organized in 1891. Some of the other clubs and organizations during that time were the Junior Order of United Workman, the Grand Army of the Republic, the Knights of Maccabes, Odd Fellows, and the Findley Lake Grange. The Findley Lake Cornet Band was well known throughout the county, and its services were in great demand at many local affairs. Later, in the 1930s, the Prohibition Band and Orchestra was started and performed throughout the area.

The success of the Lakeside Assembly brought many visitors to the Findley Lake area, but it was the lake itself that kept all of them coming back. Boating, fishing, and swimming were the very best around. Rowboating and canoeing were favorite pastimes until naphtha launches and eventually motorboats replaced them.

Fishing at Findley Lake has always been very good. Many old-timers talk about seeing large muskellunge constantly swimming around the flume area, as if teasing the people looking on. Wink Keith used to keep a blackboard of all the muskellunge caught in Findley Lake by size and weight each summer in his sporting goods store. Maisy Miles recorded on her outside door molding the size of the muskellunge and northern pike she caught each day. That door molding eventually filled up, and she used the window frames to record her daily catches. There was not a day or night that went by when she was not fishing and catching something. Findley Lake has always been stocked with various species of fish throughout the years, including muskellunge, northern pike, walleye, and perch. This has been done by the state and later by the Findley Lake Property Owners Association.

The most memorable activity in the Findley Lake area from the 1940s through the 1970s was roller-skating at the rink. Along with Ship'n Shore, this provided local teenagers with a place to hang out, meet people, and have fun. They sunbathed, swam, or water-skied at the water-ski club during the day and roller-skated at night. In the summer of 1998, the Findley Lake and Mina Historical Society held a Findley Lake Roller Rink and Ship'n Shore reunion that was attended by more than 400 people. That event brought back many memories of that special time on the lake.

Findley Lake did not fall asleep when the summer was over. The winter months provided many activities on the lake for the hardy year-round residents and visitors. Ice cutting was done on the lake for refrigeration purposes. Ice-skating was always very popular. In the 1950s, car races were held on the ice; they would race from the village area up and around the Big Island and back. Imagine doing that today!

A much smaller version of Findley Lake was known far and wide among the Eriez, Kinsmen, Sac, and Fox Indian tribes for its excellent fishing and the abundance of black bass. (Courtesy of Jerry Tenbuckel.)

Clarissa Bull stands next to a muskellunge that was caught in Findley Lake in the late 1800s. This photograph was used in the advertising and on stationery for the Lake View Hotel, which was owned by the Bull family on the southwest corner of Sunnyside Road and Main Street. This hotel eventually became a series of department stores throughout the years and has since been torn down. An empty lot is there today. (Courtesy of the Findley Lake and Mina Historical Society.)

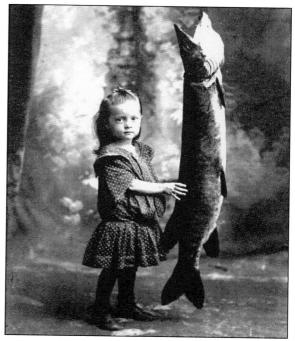

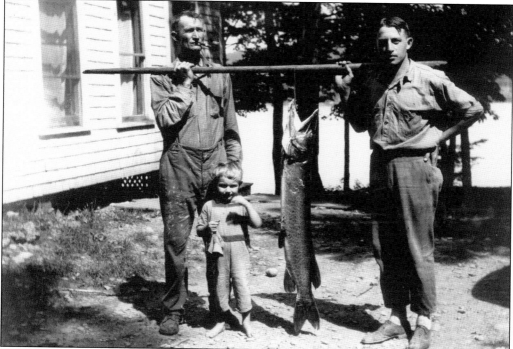

John and Les Hurlburt, father and son, hold a prize muskellunge caught in Findley Lake in the 1920s. John owned the cottage called Quaquaqa on the former Lakeside Assembly grounds. He ran the old cheese factory on North Road in the early 1900s, and his wife, Jessie, operated the Red and White Store on Main Street for a period of time in the early 1920s. (Courtesy of Randy Boerst.)

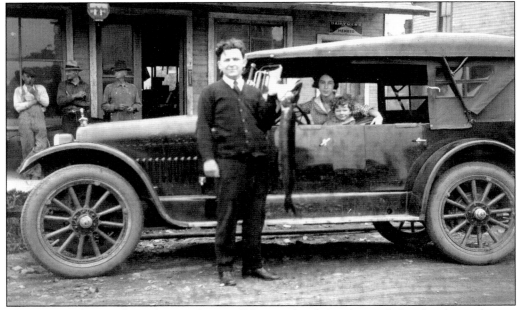

This extremely proud gentleman shows off his catch of the day with his family in the car alongside him. Peterson's Tinsmith and Hardware is pictured in the background, and to the right, Winston Odell's antiques store and the federal post office are shown. Peterson's building burned down in the 1940s. Odell's building later became Wright's Grocery Store. Today, that property is the parking lot and park next to Lakeside Market. (Courtesy of Randy Boerst.)

It took hours of rowing and fishing and lots of patience to stalk the prize catch of the freshwater lakes: the elusive muskellunge. Muskellunge normally feed only once a month, making them very difficult to catch, even for the diehard fisherman. Finally caught, a prize muskellunge is proudly hung between the boat's oars along with the trolling rod used to catch it. Here, the proud fishermen pose with their wives. (Courtesy of Jerry Tenbuckel.)

Fishing was not the only pastime in Findley Lake. Hunting was also very popular in season. In this November 1948 photograph, George Bradley (left) and Ken Neckers show off the prized black bear that Neckers killed. This photograph was taken in front of Bradley's Garage on Main Street. (Courtesy of the Findley Lake and Mina Historical Society.)

Louis Swartz, standing in the center of this photograph, entertained a group of hunters from the Buffalo, New York area each year. They hunted woodcock, grouse, and pheasants in the woods with their bird dogs. The city folks always enjoyed coming to the country and spending time in the woods hunting. John Swartz still displays two stuffed pheasants above his fireplace in his cottage on Shadyside Road that his grandfather, Louis Swartz, received from a mill customer in lieu of payment of a bill. These mounted pheasants, along with several stuffed ducks displayed throughout the cottage, date back to the early 1900s. (Courtesy of John Swartz.)

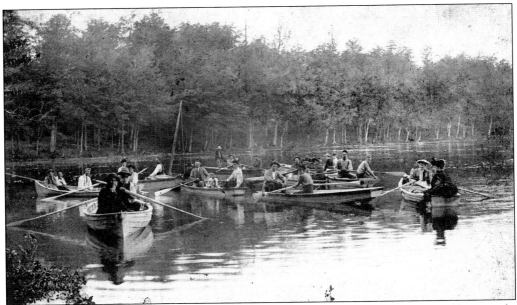

This group of boaters is getting ready for the annual pageant at the Lakeside Assembly grounds. The Illuminated Fleet appeared on Venetian Night and made the lake ablaze with gorgeously decorated rowboats as they lit up the night and serenaded the visitors on the shore. This carnival alone was worth the trip to the assembly grounds. (Courtesy of John C. Peterson.)

Jennie Ottaway and Bert Giles are pictured in a new naphtha launch on Findley Lake. This boat was 16 feet long and had a 5-foot center beam, air chambers, and all the modern improvements of the time, including cushioned seats and a stowaway canopy top. Boating together was popular for young couples, as it gave them a chance to be alone and enjoy the peacefulness and tranquility of the lake. (Courtesy of Jerry Tenbuckel.)

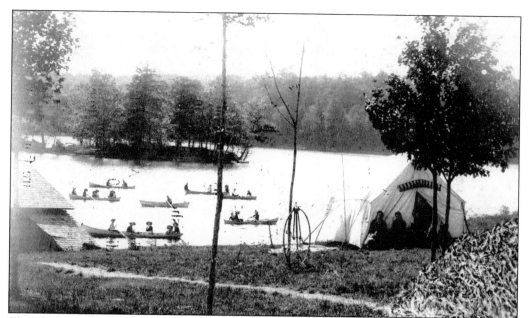

The Gallups offered a myriad of activities for each visitor to pursue while spending their summer days at Gallup's Lake House. Each guest could enjoy camping, bicycling, rowing, or just plain relaxing on the knoll and watching all the activities on the lake, including the many logs that floated down to the mill at the head of lake. The ripples of the water have a very calming effect on weary vacationers. Notice the big old-fashioned front-wheeled bicycle leaning against the tiny tree. (Courtesy of Art and Mary Cooper.)

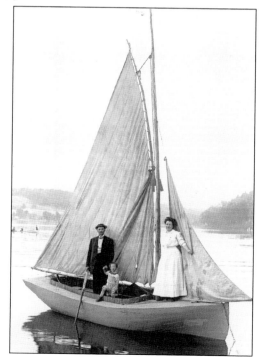

Dr. Morgan B. Tanner and his family return from an afternoon sailing on beautiful Findley Lake in August 1910. This relaxed him before he spoke in the auditorium on the Lakeside Assembly grounds that evening. Sailing is still very popular on Findley Lake, as a southwest breeze blows across the lake on a regular basis. (Courtesy of Randy Boerst.)

LaVanche (left) and Lena Gallup and Mrs. Jay Leland (center) enjoy an early-afternoon swim in Findley Lake on the beach in front of Gallup's Lake House in June 1900. The benches made from tree branches and used for resting look very uncomfortable; however, that style is popular at cottages around the lake today. (Courtesy of Art and Mary Cooper.)

The lakefront grounds of Ship'n Shore were used to sunbathe, hang out by the lake, and for family picnics. This area provided an excellent view of the upper lake and the Big Island. The swimming tower in the background was very popular to swim out to and dive off of in the early 1950s and 1960s. There was also an additional swimming and diving tower on the lower end of the lake toward the village, in front of the old gravel pit that always had the best sandy beach on the lake. (Courtesy of the Findley Lake and Mina Historical Society.)

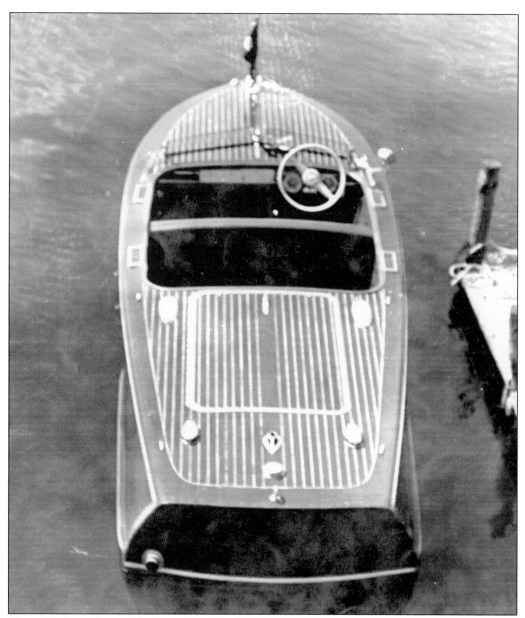

Chris-Craft is a legend. In fact, Chris-Craft is more than a legend; it is an American icon and in a class of its own. From rowboats to the fastest speedboats on earth, from the first combat landing crafts ashore at Normandy to the most coveted family cruisers, and including kit boats, Chris-Craft pioneered styling and utility in boatbuilding and has been imitated throughout the maritime world. The chairman of the board of Chris-Craft appeared on the front cover of *Time* magazine in 1959 and was credited as "the man who perhaps more than any other put the U.S. family afloat." The last production of Chris-Craft wooden, mahogany boats came in 1972. These classic lake boats were also very popular on Findley Lake in the 1950s and 1960s. Whether you were water-skiing behind one or just hopping from dock to dock around the lake, you did it in style and grace in a Chris-Craft runabout. (Courtesy of Art and Mary Cooper.)

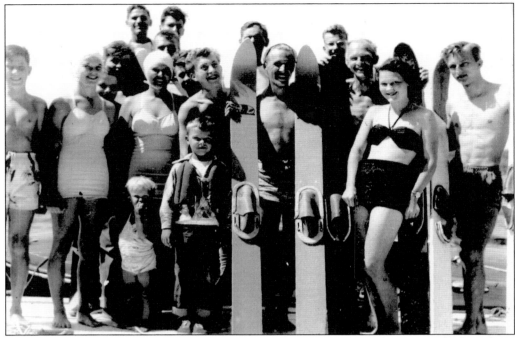

Art Cooper Jr. formed the Findley Lake Water Skiers Club in the early 1940s. The best skiers on the lake belonged to this prestigious club during that time. They competed throughout New York State against other ski clubs in various competitions as well as in annual events on Findley Lake. The Findley Lake firemen held a regatta for several years in the 1950s as a fundraiser, and this ski club was always one of the featured attractions. Each of the members performed their best skiing tricks on the water. (Courtesy of Pete Howard.)

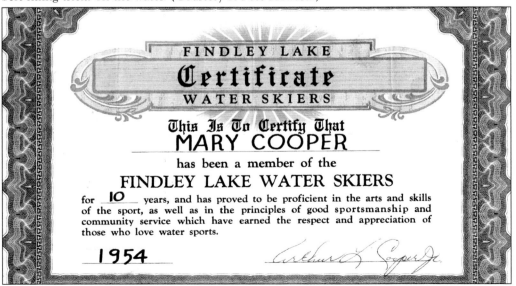

Each member of the Findley Lake Water Skiers Club earned a certificate upon completing the club's criteria of "being proficient in the arts and skills of the sport . . . good sportsmanship and community service." (Courtesy of Art and Mary Cooper.)

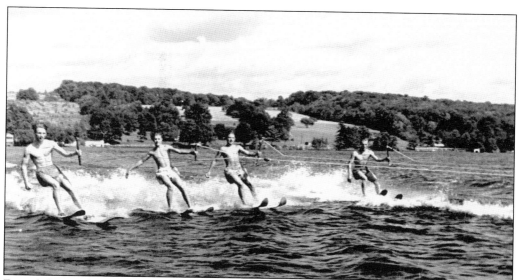

From left to right, Hal Meese Jr., Pete Howard, Ricky Meese, and Lane Jones show off their water-skiing abilities during one of the firemen's annual regattas held on Findley Lake in the early 1950s. Another one of the special treats of the water-ski club was skiing around the lake on the Fourth of July with flares in their hands to let everybody know it was time to light their flares around their property and get into their boats to head out onto the lake and watch the fireworks. (Courtesy of Art and Mary Cooper.)

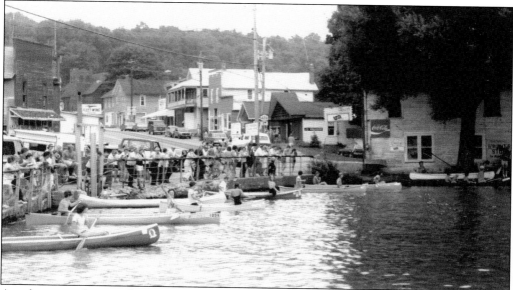

Another annual event that was sponsored by the Findley Lake Volunteer Fire Department and Wiggers Canoe Sales in Corry, Pennsylvania, was the canoe races. These were held in July in the late 1970s and early 1980s. This was a great event for kids and adults alike that attracted families from all over the area. This photograph also shows how Main Street looked at this time. Notice that the department store was still standing, although boarded up, along with Wright's Grocery Store next to the lake. The picture of Jesus had not yet graced the side of the old United Brethren Church. (Courtesy of Bob and Christie Ferrier.)

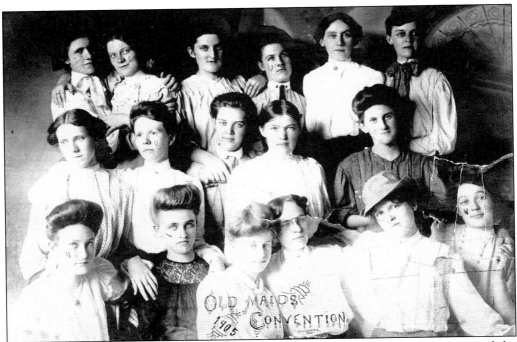

Findley Lake's most prominent young women dressed up in their Victorian best to attend the Old Maids Convention in 1905. Most likely, this occurred during one of the weeks of the Lakeside Assembly programming. Nothing about this convention has survived, except for this lovely photograph. (Courtesy of Lola King.)

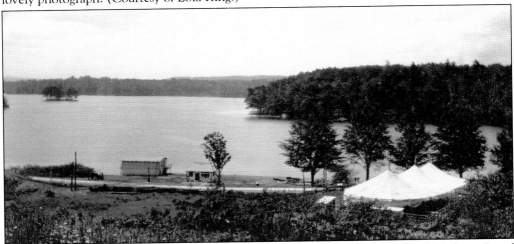

This is a great view of the early dance hall near the site of the future skating rink. Roberts Stand is also shown down by the lake before Harry and Mary Roberts expanded the building and it became so popular. Wakeley's Point is named after Bob Wakely, who owned this land and also built many of the buildings around Findley Lake: the Meadows Inn, skating rink, Charlotte Inn, and Lindy's Inn. Lindy's Inn was a drinking establishment before Prohibition and was located in the cottage across the street from Sunnyside Restaurant today. Alfred Linberg operated the inn, which was outfitted with an actual airplane propeller hanging over the bar area. (Courtesy of Randy Boerst.)

The Findley Lake Dance Club held masked balls and "sheet and pillow case dances" on a regular basis each year in the different dance and opera halls that were available around the lake. (Courtesy of Jerry Tenbuckel.)

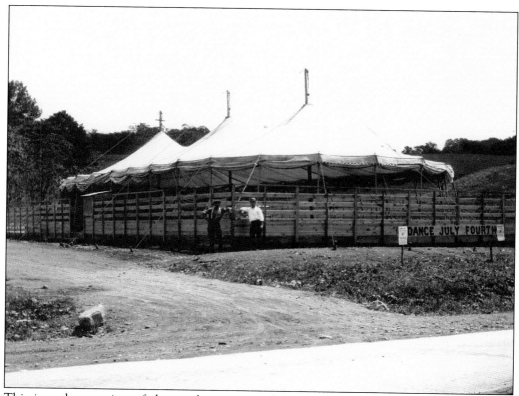

This is a closeup view of the newly constructed dance hall, a prelude to the skating rink, built by Bob Wakley. The sign in front is already advertising the annual Fourth of July dance. (Courtesy of Randy Boerst.)

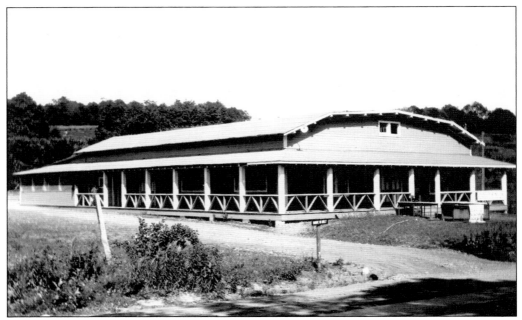

The dance halls kept getting bigger, more elaborate, and permanent over the years around Findley Lake. The Grand View Pavilion was built as a permanent dance hall in the 1920s so that it could also be used in the winter months. This building most likely became the foundation or starting point for the skating rink, which was built in the 1930s. (Courtesy of Randy Boerst.)

NEXT PRESIDENT!

PROFESSOR DILL,

Of Kansas,

A Man well qualified to instruct and entertain the People, will Speak in the Opera House at

FINDLEY'S LAKE, N. Y.,

Tuesday Evening, June 28th, 1892,

ON POLITICAL ISSUES.

DO NOT FAIL TO HEAR HIM!

Everybody Welcome.

This is an advertisement for Professor Dill from Kansas, who spoke about political issues of the day in the opera house. This speech occurred prior to the Lakeside Assembly years. The speech probably contained Professor Dill's answers to tariff concerns on imported goods coming into the United States from foreign waters, as this topic dominated the headlines between the campaigns of the two major presidential candidates, both former presidents, Grover Cleveland and Benjamin Harrison. Cleveland won the presidential campaign that year and became the first U.S. president to serve two nonconsecutive terms in office. (Courtesy of the Findley Lake and Mina Historical Society.)

Temperance was popular among groups of young people in many small towns throughout the United States, including the Findley Lake area. A Temperance Lodge was located on the assembly grounds that still stands today, although renovated. A "Slayer of the Saloon System" newsletter was published every Thursday in Findley Lake in the early 1900s. Each member had to pledge to "abstain from use of and traffic in all intoxicating liquors as a beverage." These cards are also dated from before the Lakeside Assembly years, proving that the area had a myriad of activities taking place long before the assembly years. (Courtesy of Jerry Tenbuckel.)

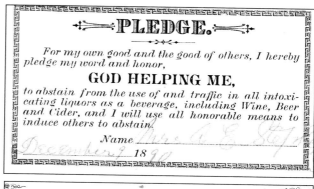

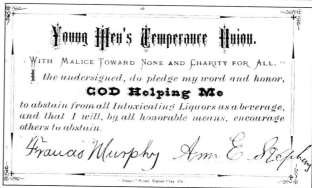

The Fern Rebekah Lodge No. 484 of Findley Lake was formed on June 12, 1912, and is still active today. This is the women's side of the Odd Fellows organization. They support heart research and the blind, offer scholarships, and operate a retirement home in Lockport, New York. Pictured in 1947 are, from left to right, the following: (front row) Grace Seltzer, Elizabeth Peterson, Lillian Johnson, and Katie Finn; (back row) Lola King, Mary Baker, Viola Doncavage, Katie Bradley, and Louella Mandeville. (Courtesy of Lola King.)

Florence and Alvin Boozel formed the Triangle Squares square-dancing group in April 1970. Art and Judy Stoddard, Alvin Boozel, Peggy Kinney, Linda Mead, Malcolm Overbagh, and Leonard and Marilyn Stutzman are pictured square-dancing one summer evening in July 1971, on a raft built on top of canoes on Findley Lake. None of the dancers ended up in the lake, and the crowd that had gathered, both on shore and on the water, enjoyed an entertaining evening. (Courtesy of the Findley Lake and Mina Historical Society.)

Horse racing on the frozen Findley Lake was a big sport in the late 1800s and early 1900s. Horses and cutters, or sleighs, were used to race one another on the ice. As you can see, huge crowds dressed in their best Victorian millinery, braving the ice and cold, attended these popular events. (Courtesy of Jerry Tenbuckel.)

A very patriotic sleigh ride is seen here on a cold winter day in Findley Lake. Everybody on this sleigh, pulled by oxen, is holding an American flag or other pennants as they travel around the lake. Could they also be Christmas caroling? Louis Swartz provided these sleigh rides each winter during the early years of Findley Lake. (Courtesy of Jerry Tenbuckel.)

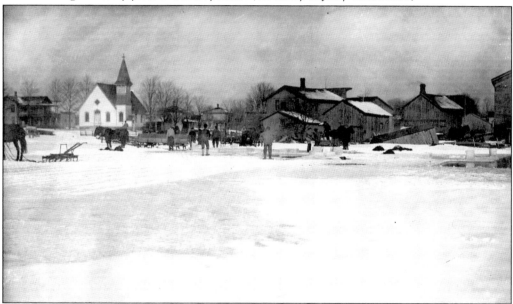

The ice-cutting, or harvesting, process was rather basic, but it was a physically grueling activity. Aided by horses, workers scraped the snow from the ice surface, sawed the ice into blocks, opened a channel, and floated the massive blocks of ice to the many icehouses located along the shoreline in the village. Spring-fed Findley Lake's pure, high-quality ice was insulated with both straw and sawdust and stored during the winter months in these icehouses. During the summer, the harvested ice was sold to local cottage owners around the lake and was shipped to neighboring towns to be sold there. Many of the old buildings and barns shown in early photographs along the lake are these icehouses. (Courtesy of Mary Norcross.)

Ice-skating on Findley Lake has always been a favorite winter pastime for many local residents and visitors, and it still continues today. Shoveling off the ice in front of their cottages, starting a fire, and skating together as a family has been a practice shared by residents for many years. It was very popular in the 1920s for young couples to skate out to the Big Island and back to the village on a moonlit night. Of course, this was well before snowmobiling became so popular. (Courtesy of John Swartz.)

Can you imagine racing your car around the Big Island today? This event actually occurred in Findley Lake in the late 1950s. Look at the huge crowd that gathered to watch those who were daring enough to take a spin in their cars on the frozen ice. Jim Boerst, the author's father, did this one winter, unbeknown to his mother, of course. This picture was taken near the village where the official starting point was. (Courtesy of Bob Skellie.)

Six

THE EARLY YEARS
OF PEEK'N PEAK

"Go ahead fellows, if you can move that road at the foot of the hill," Otto Schniebs, renowned ski resort architect, proclaimed in December 1963, and the rest is history at the Peek'n Peak Resort and Conference Center.

An enterprising group of five men and their wives from the Clymer, New York area are responsible for the start-up and development of the Peek'n Peak resort complex, which took just a year's time to complete. Phillip Gravink, chairman of the board and the only skier of the group, was a farmer and operated a dairy-equipment business in Clymer. E.W. "Jim" Caflisch, president, operated a wholesale and retail lumber business in Clymer. George Boozel, vice president, operated a farm in French Creek, New York. Myrl Babcock, treasurer, also operated a farm in French Creek. Jack Dean, secretary, sold farm insurance in Westfield, New York.

These men tossed the idea around in casual conversation for over a year. "The old Pekin Hill would make a good ski slope, wouldn't it?" "Sure would." "See you around sometime, fellows." The conversations would go like that until the group met seriously in January 1963. Pekin Hill is a little mountain. It lies like a punctuation mark at the end of the Appalachian mountain chain, standing tall above the good, flat farm land below. After all the conversations, they finally decided to have a professional look over the area. Otto Schniebs was impressed with the snow conditions and gave them the go-ahead if the road could be moved.

A financial proposal was drawn up and presented to the Bank of Jamestown, which agreed to finance the new project if the corporation named Western Chautauqua Recreation could come up with $80,000 from the sale of stock. That stock (class A and B) was sold in less than two months to local people, and the bank approved the loan of $120,000 for the new development. The five men shared the duties of development and management of the resort. Phil Gravink was in charge of the lifts and trails, assisted by George Boozel. Babcock was in charge of utilities. Caflisch handled the lodge planning and construction, and Dean handled the publicity for the new organization.

The first winter saw a total of 66 ski days, with 10,362 people skiing from December 8, 1964, through April 4, 1965. The attendance and the number of ski days gradually increased until 1971, when there was a total of 276 inches of snow that winter, 114 total ski days, and almost

113

118,000 people using the 15 ski slopes and trails. In 1971, the board of directors purchased Peek'n Mountain in Youngsville, Pennsylvania.

The directors realized very early on that in order to be successful they had to develop Peek'n Peak into a year-round resort and could not rely on skiing alone to make ends meet. They wanted to be the pioneers in building a new breed of resorts by the 1980s. The factor that they considered first was that the census figures showed that the age group of people 25 to 35 years of age would grow 60 percent by 1980. This group, with their young families, would be the largest purchasers of active-participation recreation, including skiing, golf, and tennis, and their vacation habits would be typified by one-day drives to destinations. With their growing affluence, they would demand high-quality food and services with a wide variety of activities for themselves as well as their children. The second factor that they considered was that multi-day seminars outside the typical metropolitan centers were starting to become common in American businesses. These seminars typically combined work, relaxation, and recreation for the advancement of sales, professional training, and high-level company policy making.

With this new concept in mind, the following activities occurred: Peek'n-on-the-Lake was purchased and opened on Findley Lake; Inn-at-the-Peak was built; an 18-hole golf course was built; additional buildings and ski slopes were constructed; condominiums were planned for; and a tennis, swimming, and conference center was developed. This $3.5 million building program was both good and bad for Peek'n Peak. It enabled Peek'n Peak to become the fourth largest ski resort in New York, but it also caused the corporation to go into state receivership because of being overextended. The aggressive building plans, coupled with cost overruns, inflation, the energy crisis, and several years with very little natural snowfall, caused the 11-year-old operation to almost close.

Peek'n Peak emerged out of state receivership after 10 long years. During the receivership years, daily operations continued, but only necessary repairs were made. No construction or expansion took place. In this time period, Peek'n-on-the-Lake and Peek'n Mountain were also sold. Norbert and Eugene Cross became private owners of Peek'n Peak in the summer of 1988. The Crosses made a commitment to continually reinvest their money into expanding and upgrading the facilities. Families, friends, and corporations from around the world have enjoyed this quaint European-style village, complete with Tudor architecture. Its prestigious RCI Gold Crown rating is duly appreciated with the diverse amenities that accompany this full-service, four-season resort today. Welcome to Sherwood Forest!

This stock certificate is from the initial stock offering of Western Chautauqua Recreation to develop the Peek'n Peak ski resort. (Courtesy of Art and Mary Cooper.)

Construction of the Old English lodge named Peek'n Inn began in 1963. It was the dream of Helen Caflisch, who read every available book and magazine on post-Renaissance England she could find. It was proclaimed an architectural wonder of the area at the time it was built. This was an Old English–style country lodge with all the architectural and atmospheric intrigue of a feudal manor. From the hand-split shakes on the outside to the leaded-glass lanterns hanging on the iron chains in the lounge, nothing was written down, nor were any blueprints produced. Helen Calfisch would tell Don Rothenburger, operations manager, "This is what I want," and he would in turn tell the construction crew, "This is how you do it." The natural setting on a lonely and deeply forested hillside inspired the creation of this building with its steep-pitched roof, vaulted ceilings, and natural woodwork. The 12- by 12-foot fieldstone fireplace was original to a settler's cabin, which was last known to be occupied by a hermit in the early 1900s. The building originally housed the first-aid room, ski patrol office, restrooms, storage, and a nursery on the first floor. The second floor contained the ski shop, cafeteria, and observing areas. The building was only half finished for the grand-opening celebration on December 19, 1964. The lodge has more than doubled in size since 1964. The school bus to the left in this photograph housed the business offices and ticket sales. (Courtesy of Peek'n Peak.)

Inside the Peek'n Inn are tables made of federal plank wood (two inches thick) stained dark, which measure seven by three feet. They have solid end supports on which is carved an authentic Robin Hood design, a heart-shaped cutout that resembles the Pennsylvania Dutch Heart. The students of Clymer High School researched this design before the tables were built. (Courtesy of Peek'n Peak.)

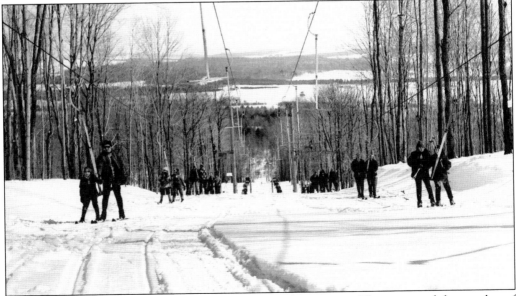

A second T-bar was added in 1965, the second year of operations. This increased the number of ski lifts to three. Some lights were also added for the new night skiing on Thursday and Friday evenings until 10:30 p.m. There were a total of 72 ski days, 231 inches of recorded snowfall, and 16,973 skiers using the slopes the winter of 1965–1966. (Courtesy of Peek'n Peak.)

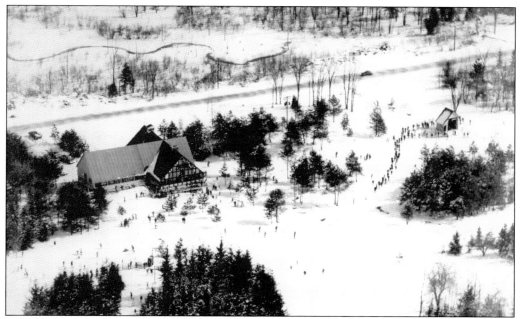

A 1965 view from atop Pekin Hill shows the original six ski slopes converging in front of Peek'n Inn. Otto Schniebs, a world-renowned ski expert from Wilmington, New York, designed the original layout of the ski slopes. Schniebs, known as the father of modern American skiing, was the Olympic ski coach in the 1950s as well as ski coach at Dartmouth College and several other universities. He was also the architect of more than 70 other ski resorts across the world. (Courtesy of Jeff TeCulver.)

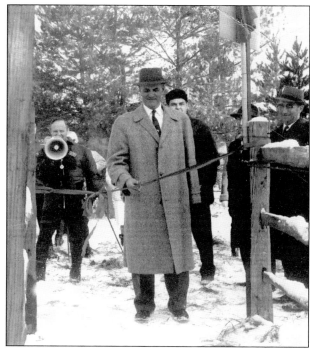

On December 19, 1964, the grand opening of Peek'n Peak took place. The ski slopes officially opened on December 5, 1964. The grand-opening ceremonies drew 2,500 people on an icy 18-degree day, with the freshly groomed slopes holding a bare three-inch base of snow and a dusting of fresh powder provided from snow that had fallen the night before. Shown cutting the ribbon on that day is Joseph Nakoski, the French Creek highway supervisor. Behind him are, from left to right, Jack Dean, Jim Calfisch, unidentified, and Edward Beckernick, the French Creek supervisor. (Courtesy of Peek'n Peak.)

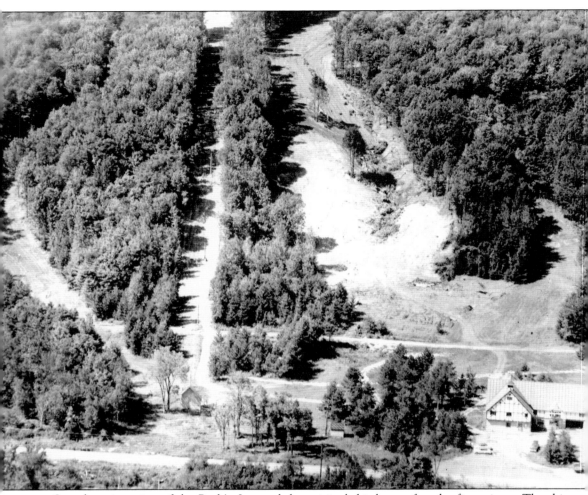

Seen here is a view of the Peek'n Inn and the original ski slopes after the first winter. The ski slopes shown are Long Bow, the 2,400-foot expert slope; two T-bar, 2,100-foot ski lift areas; Will-o'-the-Wisp, a 2,300-foot intermediate slope; and Will Scarlet's Secret, the 3,700-foot novice and intermediate slope that Otto Schniebs called "the most interesting trail of all." Also shown in this picture is the original road, which had to be moved in front of Peek'n Inn. That road was a French Creek town road that handled a lot of traffic a century ago. At that time, it served at least 34 homesteads. In 1963, it led to two farms and one home. The French Creek town board agreed to move the road for $500 and also agreed to change the name from Old Road to Ye Olde Road, which kept it in context with the Old English theme of the resort, but the decision will probably confuse historians 200 years from now. The original land making up Peek'n Peak consisted of 500 acres around Pekin Hill, which also contained a 25-year-old stand of spruce and pine trees. (Courtesy of Peek'n Peak.)

Don Rothenburger, operations manager during the developmental years at Peek'n Peak, is pictured with his hand on his chest in the background, observing the construction progress of a bow wheel being constructed on the third T-bar ski lift. The bow wheel was used to turn the cable at the end of the run and return the T-bars back down the slopes to pick up new skiers and bring them back up the hill. (Courtesy of Peek'n Peak.)

Phil Gravink (left) and Myrl Babcock map out the board of directors' 10-year plan for the growing resort. This plan would include the Inn-at-the-Peak, an 18-hole championship golf course, an enclosed swimming pool, enclosed year-round tennis courts, a major snowmaking system, a municipal-type sewage system, a commercial water system, a vacation home subdivision, and major improvements to the ski lodge and slopes. By 1971, Peek'n-on-the-Lake in Findley Lake and Peek'n Mountain in Youngsville, Pennsylvania, had been acquired and were in full operation. (Courtesy of Peek'n Peak.)

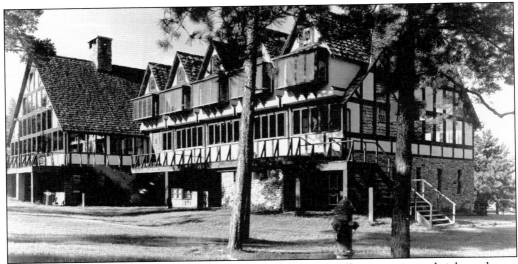

The newly enlarged Peek'n Inn was completed with business offices upstairs and ticket sales on the first floor, as pictured in 1969. The staff could finally stop working out of the old school bus. Construction projects that year also included the installation of the first chair lift and three new ski slopes and trails, bringing the total to 11. Sunday early-bird skiing was introduced. A total of 193 inches of fresh snowfall was recorded, which enabled Peek'n Peak to operate for a total of 104 ski days that winter and bring 69,203 skiers to the growing ski resort. (Courtesy of Peek'n Peak.)

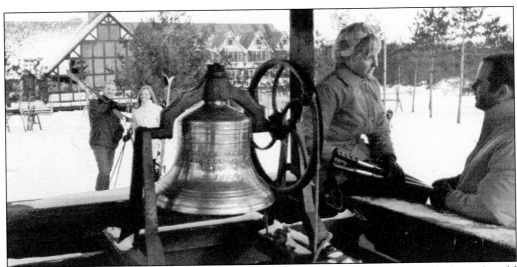

Some early skiers hang out at the ski school bell kiosk. This bell was originally from the old Findley Lake Union School on School Street. It is no longer at Peek'n Peak because somebody would steal it from the grounds. The ringing of the bell always indicated the start of ski school, and the 40 ski instructors on staff were ready to begin their daily lessons. Skiing lessons were always provided from the first day, with private lessons anytime and group lessons daily. Also, special group ski lessons would be arranged for any individual school, club, or group. Ron Hamilton was the ski school director during the early days of Peek'n Peak's operation. This photograph also shows the view of Peek'n Inn from the slopes, before it was remodeled for yet a third time. (Courtesy of Peek'n Peak.)

The Sugar'n Ouse was built in 1971–1972. This building was constructed as a second ski lodge with fine food, a different menu than the main lodge, and an atmosphere and design that was consistent with the natural terrain of the surrounding area. It also kept with the Robin Hood, Old English theme. The specialty of the Sugar'n Ouse was fresh pancakes that were served all day long with the real maple syrup that was produced in the building. The building was originally used to produce maple syrup and maple sugar products. Area groups and clubs would tour the operations and especially enjoy learning about the process of maple syrup production. This is no longer done at Peek'n Peak, although the Sugar'n Ouse still remains as a second ski lodge. (Courtesy of Peek'n Peak.)

Western New York ranks very high in the natural production of maple sugar. During late winter and early spring, maple trees indigenous to the northeastern states are tapped to release their liquid, which is then made into syrup. The process was discovered first by Native American tribes who used the maple sugar as a means of bartering. Small holes are drilled through the tree's bark, spouts are inserted into these holes, and metal buckets with lids are hung to collect the draining liquid. Cool nights and warm days make the liquid just pour out of the maple trees. Pictured is Raymond "Rakie" TeWinkle in front of the original evaporator used to produce maple syrup in the Sugar'n Ouse. (Courtesy of Peek'n Peak.)

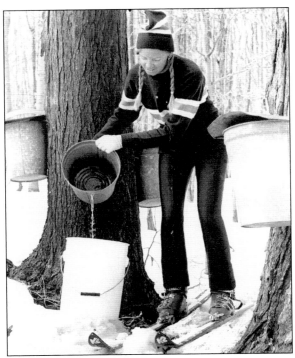

Mary Myers, who was one of the original ski instructors at Peek'n Peak, is gathering the freshly produced liquid from a couple of maple trees on the ski slopes. This liquid was then taken down the slopes to the Sugar'n Ouse to be boiled down into maple syrup and maple sugar products. She is also wearing the original ski instructor uniform and hat. At that time, there were over 40 instructors working at the Ron Hamilton Ski School. This picture was probably taken as a publicity shot, because ski instructors would never gather the liquid sap nor ski off the official groomed ski slopes between trees. (Courtesy of Peek'n Peak.)

Geneva Hawkins was the longtime office manager at Peek'n Peak. She is shown talking to a customer about the upcoming season in the newly constructed business offices added onto Peek'n Inn. The 1969–1970 ski season produced the most ski days, 125. This record would last for almost 20 years. A total of 227 inches of fresh snow blanketed the 13 ski slopes that winter. The price for skiing Monday through Friday that year was $6 a day, and a total of 103,992 people skied during that most profitable season ever for the directors of Peek'n Peak. (Courtesy of Peek'n Peak.)

After several years in operation, the directors of Peek'n Peak realized that in order to survive and produce profits, they needed to develop a year-round resort complex, one that did not rely on natural snowfall alone. Developing a golf course was part of the plan. Pictured above are Bill Craday (left) and lower golf course architect Ferdinand Garbin looking over plans for the design of the first nine holes of what would become the lower golf course in 1972. The picture below shows what they had to work with and the amount of land clearing that had to be done to make this course. The first nine holes opened in the spring of 1973. It was so successful that nine more holes were constructed and opened in the spring of 1975, creating an 18-hole, 6,330-yard golf course on 150 acres of gently rolling flatland with wooded fairways. The golf course is still being used today. (Courtesy of Peek'n Peak.)

In 1970–1971, the annex building was constructed next to Peek'n Inn to help ease the congestion of the fast-growing resort complex. The ski school and ski rental business were immediately moved into this new building. Also that year, a second J-bar was added, bringing the total number of lifts available to skiers to six. By this time, there were 15 slopes and trails, and a lift ticket to use all these new areas was only $6.50 on the weekend. Peek'n Peak enjoyed a very welcoming 114 ski days that year. Since the very beginning, the goal of the directors was to have 100 ski days each season. This is still true today. (Courtesy of Peek'n Peak.)

This picture from the winter of 1972 shows a bird's-eye view of the rapidly expanding ski resort with a parking lot overflowing with vehicles. Business continued to grow, and profits were being reinvested into the long-range plans of the founders. There was a total of 93 ski days that winter. This was to be the beginning of less than average snowfall for the Findley Lake area during the next four years. Construction projects included adding chair lift No. 3 and expanding chair lift No. 1. An additional ski slope was also added, bringing the total to 16 slopes and trails. (Courtesy of Peek'n Peak.)

Responding to the changing habits of the American people, in addition to keeping with their original 10-year development plan, the directors started building what would become the Inn-at-the-Peak in 1972. The whole idea was to take advantage of the many families visiting Peek'n Peak by offering them hotel accommodations, indoor tennis courts, an indoor swimming pool, and high-quality food. Once they had the families here, they did not want to let them leave and spend their money on lodging someplace else. In addition, meeting places were developed for the increasingly popular multi-day business seminars. (Courtesy of Peek'n Peak.)

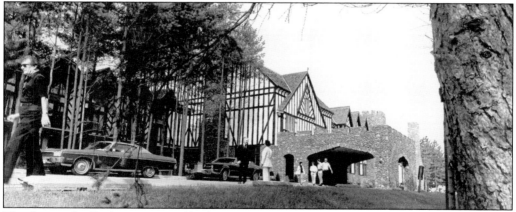

The Inn-at-the-Peak was originally designed in the style of a Jacobean manor after Evelyn Babcock and her twin sister, Helen Caflisch, both wives of two of the founders, visited England for the first time. Construction lasted almost two years because a change was made from constructing 90 hotel rooms to building 60 two-room suites, each containing two beds and one sofa bed. This construction change produced cost overruns that would eventually catch up with the enterprising five founders. The Inn-at-the-Peak has been added onto and remodeled several times over the years but still retains its Old English charm that Evelyn and Helen first envisioned. This grand building continues to be the focal point of the year-round resort today. (Courtesy of Peek'n Peak.)

The interior of the Inn-at-the-Peak is filled with many appointments from the 19th-century Reed Mansion (on Sixth Street in Erie, Pennsylvania) that were purchased at an auction before the stately building was torn down to make way for the new AAA building in 1970. The Reed Mansion was constructed in the 1860s by Gen. Charles Manning Reed and was given as a wedding gift to his son, also named Charles. Evelyn Babcock and Helen Calfisch carefully photographed each room and tagged and coded all the massive components before they were disassembled and put into storage. These women had already designed in their minds the next building at Peek'n Peak, where they would use this historic woodwork and furniture. (Courtesy of Peek'n Peak.)

When the Inn-at-the-Peak was built in 1973, the leaded windows, glass chandeliers, paintings, stained glass, double doors, wainscoting, intricately carved woodwork, fireplace mantles, and staircases were painstakingly reassembled throughout the inn. If pieces of woodwork were missing or damaged, exact replicas were made to fit in the missing places. Two private dining rooms, the Cherry Room, which had been the library in the Reed Mansion, and the Reed Room, off the Royal Court Dining Room, were also created to look exactly how they did before the Reed Mansion was torn down in 1970. The ebony-dyed English oak woodwork, hand-carved panels, and leaded-glass windows with shutters were all imported and reconstructed by Gen. Charles Reed from a 300-year-old German castle, making many of these one-of-a-kind appointments over 400 years old. (Courtesy of Peek'n Peak.)

The board of directors at Peek'n Peak realized after a few winters that relying on natural snowfall alone did not make good business sense. The winters were very inconsistent, and one bad winter could have disastrous results on the constantly expanding operations. The first snowmaking machines were installed during the 1972–1973 ski season, and just in time. That ski season produced only 80 ski days, even with the one snowmaking machine. That year Peek'n Peak was open for business, for the first time, seven days a week. Additional snowmaking equipment was added the next season for the slopes by the Sugar'n Ouse. Even with this additional snowmaking equipment, there were only 91 ski days in the 1973–1974 season, almost two weeks short of the goal of 100 ski days. (Courtesy of Peek'n Peak.)

Members of the original Peek'n Peak junior race team pose for a picture before competing against a team from the Buffalo Ski Club. The junior race team is the resort ski racing club for boys and girls ages 6 to 19. Participants must be able to ski all the terrain at Peek'n Peak, have the ability to load and unload from the ski lifts on their own, and have a strong desire to race competitively. Christmas Camp provides the introduction to competitive racing for these youngsters for three days during late December. After this camp, those who do well have the opportunity to join the junior racing team. The competitive racing events, including slalom and giant slalom, are held at ski resorts throughout New York State. (Courtesy of Peek'n Peak.)

BIBLIOGRAPHY

"Additional History of Findley Lake," *Lakeside Chautauqua Magazine* 2 (1910): 2–3.

Boerst, Randy. "Findley Lake: Looking Back through the Years." Report, Findley Lake, New York, 2002.

Boozel, George and Ginger. Interview by author. Clymer, New York, September 13, 2002.

Chautauqua Ski Slopes, December 1964.

Chautauqua Ski Slopes, January 1965.

Cooper, Art and Mary. Interview by author. Findley Lake, New York, October 12, 2002.

Donelson, Rev. Glenn. *Camp Findley Golden Anniversary Bible Conference* (New York: Christian Camping International, 1986).

Ferrier, Robert and Christie. Interview by author. Fairview, Pennsylvania, September 23, 2002.

Findley Lake Property Owners, Inc. v. Town of Mina, 154 NYS 2d 776 (1956).

Findley Lake Property Owners, Inc. v. Charles W. Parkhurst, 154 NYS 4d 3863 (1963).

Findley Lake Breeze. February 22, 1887.

Findley Lake and Mina Historical Society. *Triquasquicentennial Findley Lake Boat Tour.* Narrative report, Findley Lake, New York, 1999. Mimeographed.

Jack, Walter. "The Story of Findley Lake," *Erie Times-News,* December 31, 1950, section E-17.

Jack, Walter. "Here's a Look at Findley Lake Fifty Years Ago," *Erie Times-News,* December 7, 1956, section E-14.

Johnson, Karen L. "Findley Lake Landmark Makes Lasting Impression," *Corry Journal Weekend,* February 26, 1994, section 1.

Keith, Millie. Letter to author. Findley Lake, New York, November 18, 2002.

King, Lola. Interview by author. North East, Pennsylvania, September 26, 2002.

Loncharic, Meg. *Erie Times-News,* January 22, 1999, section A.

Loncharic, Meg. *Erie Times-News,* January 31, 1999, People section.

The Mariners' Museum. "Chris-Craft History, 1861–2002." www.chriscraftboats.com.

McAlister, Neil H. "About the Show: Brigadoon." www.corvalliscommunitytheatre.org/shows/brigadoon/theshow.htm.

Meese, Harold F. "Notes on the Title to Findley Lake." Report, Findley Lake, New York, 1964. Mimeographed.

Norcross, Mary. Interview by author. Findley Lake, New York, October 14, 2002.

North East Sun, August 8, 1914.

Ottaway, Lee. "The Story of Mina." Presentation at annual Chautauqua County Historical Society meeting, Findley Lake, New York, October 1956.

Peek'n Peak Ski Center. Clymer, New York. *Peek'n Country News,* summer 1971.

Peek'n Peak Recreation Inc. Clymer, New York. *Peek'n Country News,* winter 1974.

Robertson, Carlton A. "Incidents in the History of the Township of Mina." Report, Findley Lake, New York, 1936. Mimeographed.

Sesquicentennial Committee. *Mina=Findley Lake Sesquicentennial 1824–1974.* 2d ed. Pennsylvania: Gohrs Printing Service, 1997.

Stauss, Lysle, "At a Project," *Erie Times-News,* October 18, 1964, section E-3.

Swartz, John. Interview by author. Findley Lake, New York, October 29, 2002.

Watt, Alexander. *The Slayer of the Saloon System* (Findley Lake, New York: Purity, Protection Press, May 24, 1900).

Young, Andrew W. *History of Chautauqua County, New York, From its First Settlement to the Present Time, with Numerous Biographical and Family Sketches* (Buffalo, New York: Printing House of Mathews and Warren, 1875).